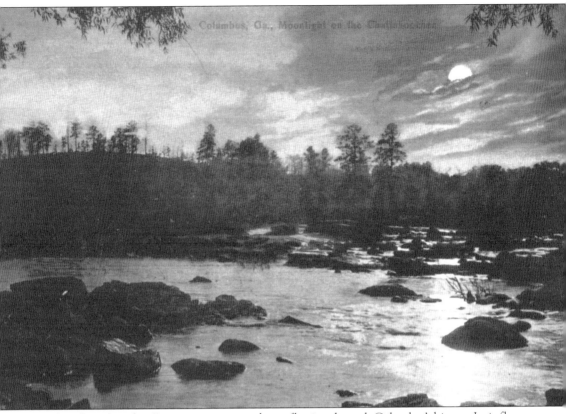

The Chattahoochee River is a consistent theme flowing through Columbus's history. Its influence on the city has been immense, even from the very beginning, and it will undoubtedly continue to be a driving force far into the future. (Courtesy of Columbus State University Archives.)

ON THE COVER: By the 1920s, automobiles were becoming more prevalent. This is true of Columbus, where an early traffic jam has caused some congestion at the corner of Twelfth Street and Broadway. The Roaring Twenties were also a time of mass consumerism. People were out and about spending money by shopping, experiencing new entertainment venues, and eating out at new restaurants. (Courtesy of Columbus State University Archives.)

IMAGES of America
COLUMBUS

David M. Owings

Copyright © 2015 by David M. Owings
ISBN 978-1-4671-1404-2

Published by Arcadia Publishing
Charleston, South Carolina

Printed in the United States of America

Library of Congress Control Number: 2014957358

For all general information, please contact Arcadia Publishing:
Telephone 843-853-2070
Fax 843-853-0044
E-mail sales@arcadiapublishing.com
For customer service and orders:
Toll-Free 1-888-313-2665

Visit us on the Internet at www.arcadiapublishing.com

Contents

Acknowledgments		6
Introduction		7
1.	Frontier Town	11
2.	Antebellum Columbus and the Civil War	25
3.	Mill Town	53
4.	A New Columbus	101
Index		127

ACKNOWLEDGMENTS

There are many institutions and people I would like to thank for preserving the history of Columbus and helping to make this book possible. Foremost is the Columbus State University (CSU) Archives. Without its long-standing commitment to collect and preserve the history of the region, this publication would not have been possible. The collections from the CSU Archives provided the majority of images in this book and, unless otherwise noted, all images appearing in this book are from their collections. Other institutions whose collections have been invaluable and are included in this work are the Columbus Museum, Historic Columbus Foundation, W.C. Bradley Co. Archives, Georgia Archives, Library of Congress, National Archives, and private collections. I want to thank all of these institutions and the many people working in them for their dedication to preserving the past. There were also many people, too many to list individually, who helped with reviewing this publication; my thanks go out to all of you.

INTRODUCTION

The Columbus, Georgia, area is a natural spot for habitation due to the roaring Chattahoochee River. The city's unique location on the river also makes it a natural center of trade and industry because of its position at the beginning of the navigable portion of the river on the Georgia fall line, where the Piedmont Plateau meets the Coastal Plain. The city has largely relied on the river for its success and as its defining characteristic. However, Columbus cannot be limited to just a river town. Over the years, it has experienced a diverse range of people and businesses calling the city home, as well as many travelers and visitors passing through. Periods of economic success and depression populate the city's past, as well as staunch traditions and times of reinventions. All of this contributes to the city's identity and the story of its past. There is no single narrative or identity that defines Columbus, but instead, there is a multitude of voices, all with a different story to tell. Indeed, the Columbus area has a long and rich history with many different stories, and it is these stories that this book seeks to highlight as it explores Columbus's past.

The earliest residents of the Columbus area were Native Americans who identified themselves as Creeks, specifically the Lower Creeks. They formed the towns of Cusseta and Coweta along the banks of the Chattahoochee relying on the river for food and water, as well as a means of transportation to trade with other tribes and Europeans, such as the Spanish and British. The British found favor with the Lower Creeks and maintained friendly relations. Indeed, many Lower Creeks fought alongside the British during the American Revolution and remained hostile to the newly founded United States after the revolution. Other towns sought to remain neutral, such as Cusseta, and others allied with the United States. For example, on March 27, 1814, William McIntosh, a Lower Creek chief, fought with other natives alongside Andrew Jackson against the Upper Creeks in the Battle of Horseshoe Bend, Alabama. He realized that the American appetite for westward expansion was insatiable and convinced many other Creek chiefs to agree to the Treaty of Indian Springs in 1825, ceding all lands east of the Chattahoochee River to the United States and removing the natives to an equal portion of land west of the Mississippi River. This made way for an influx of settlers and would set the stage for many new towns, one of those being Columbus.

The City of Columbus was formally established in 1828 by the State of Georgia as a planned city. Many people recognized and sought to take advantage of the unique geological location, and so they moved quickly after the land was ceded from the Creeks. These geological qualities would contribute significantly to Columbus's early success. Located at the beginning of the navigable portion of the river meant one could travel from Columbus to the Gulf of Mexico. This was critical in the days of steamboat travel as Columbus supplied cotton to buyers around the world, and nearby farmers, merchants, and other businesses came to Columbus to buy and sell goods as well. The majority of cotton that came to Columbus was sold internationally, but some of it was also consumed by the local textile mills. Columbus's place on the fall line allowed the development of hydropower, which powered the city's many textile mills allowing raw, unprocessed cotton to

be transformed into a variety of textiles. By the time of the Civil War, Columbus was one of the leading industrial centers in the South, with many calling it the second most industrial southern city after Richmond. Its importance to the Confederacy, and as a military target to the Union, would be pivotal during the war years.

The number of industries in Columbus in the years leading up to the Civil War is staggering. Mills such as the Eagle Mill, City Mills, Clapp's Factory, Variety Mills, and the Howard Factory formed the backbone of the city. Other industries included the Columbus Iron Works, the Naval Manufacturing Yard, and Haiman's Sword Factory, just to name a few. However, industry was not the only characteristic of life in early Columbus. Religion, education, and entertainment were all staples of Columbus life. A number of schools were also established, although in the beginning, these were private endeavors rather than publicly supported. There were also theaters and other venues for plays, musicals, and other traveling acts. White citizens would have dominated these activities, as slavery was a reality in the city. By 1860, slaves made up nearly 40 percent of the population in Muscogee County. However, this would soon change. Columbus's location in the Deep South may have protected it from the front lines for most of the war, but it would not escape the horrors of battle indefinitely.

After sweeping through Selma and Montgomery, Alabama, Union general James Wilson's cavalry raiders set their sights on Columbus. Residents of the city were largely unprepared, as they were certain the Union army would turn south from Montgomery and head to Mobile, Alabama. Confederate general Howell Cobb led a limited defense of Columbus consisting of around 3,000 soldiers with a small network of earthworks. However, this would not be nearly enough to mount a proper defense of the city. On April 16, 1865, Wilson's army, numbering nearly 14,000 strong, arrived and engaged the defenders. Most of the fighting took place on the Alabama side of the river in the town of Girard, as Cobb sought to hold the Union forces at the river. The Confederates burned the Dillingham Street Bridge, a covered wooden bridge at the time, as Union forces tried to cross it. This was a deliberate plan so that the Confederate defenders could concentrate on the Fourteenth Street Bridge. Union forces assaulted that bridge at night, and in the ensuing chaos, Cobb's plan to direct cannon fire onto the Union forces failed as Confederates became mixed with Union forces. As the Confederates retreated and the Union pursued, Cobb would not have his cannons fire onto his own soldiers. With the Confederates in full retreat, Wilson had won an easy victory. The occupying Union forces burned any industry that would support the Confederate cause but left the rest of the city alone. The burning of Columbus industry was an action Wilson would later regret, as Robert E. Lee's Army of Northern Virginia had surrendered just days prior on April 9, an event Wilson did not know about at the time of the battle. Because of this, the Battle of Columbus is often called the last battle of the Civil War. The war may have been over, but there were still many difficult battles ahead, as Columbus needed to rebuild and go through Union reconstruction.

The rebuilding of industry happened rapidly, and the Eagle Mill was one of the first rebuilt. To signify its rebirth from its ashes, it took on a new name, becoming the Eagle and Phenix Mill. Other mills followed suit as well as other industries such as the Columbus Iron Works. Other aspects of Union reconstruction were largely uneventful for Columbus. However, one incident in particular that stands out is the murder of George W. Ashburn. Ashburn was a Columbus resident who became known as a "scalawag," a person who abandoned traditional southern ideals and supported the predominantly northern Republicans. Ashburn was a staunch advocate of African American equality, and it was for these beliefs that he lost his life. In 1868, upon his return home to Columbus from Atlanta, a mob stormed his residence and murdered him. Twenty-three people were arrested and put on trial by the Union military, but no verdict was ever issued as political deals were made to prevent it. These deals, particularly the agreement to ratify the Fourteenth Amendment, led to the end of military reconstruction in 1877. By that time, as trade was resuming in the aftermath of the Civil War, Columbus again prospered as it returned to its status as an economic powerhouse.

Throughout the late 19th and early 20th century, Columbus continued to grow. The city was caught up in the Progressive movement that was sweeping the country during this time. In short, progressives strove to better the human condition. Hospitals, public schools, a public library, and public drinking water all came to Columbus as the city sought to improve itself. After the Civil War, Columbus industries rebuilt and saw renewed success, but depressions in the 1870s and 1890s resulted in many businesses suffering and some closing. However, for the most part, the mills remained steady, sustaining Columbus during these difficult times. Weathering the depressions, by the early 1900s, there was renewed growth across the board leading Columbus into the Roaring Twenties. Another event that fueled Columbus expansion was the establishment of Camp Benning in 1918. Not all of this growth and prosperity could be sustained indefinitely, however. The Great Depression would have dire consequences for Columbus. The textile mills were hit hardest, and the Depression would ultimately be their doom; they would never recover. Roosevelt's New Deal programs provided relief and a path to recovery, with the wartime spending of World War II ultimately bringing the Depression to a close. By the late 1940s, with the textile mills in decline, Columbus was beginning to look like a much different place. The city would soon see many changes, as it was forced to evolve and reinvent itself.

As the country changed, so did Columbus. Military spending in the aftermath of World War II skyrocketed, and that included Fort Benning. Its rapid growth continued to influence the Columbus community significantly. Its steady supply of new residents fueled Columbus's growth and stimulated the economy. In addition to economic impact, there has been a tremendous social one as well. The military's presence created an incredibly diverse community within Columbus with a vast range of ethnicities and economic backgrounds as natives from other states came to call Columbus home. Columbus College, founded in 1958, was another major catalyst for change in the city, as well as a prominent leader in many areas, including civil rights. The college peacefully integrated in 1963, leading the city through this challenging period. Although there were certainly many challenges involved with desegregation, Columbus was much less chaotic than elsewhere in the Deep South. There was a string of fire bombings in 1971, but no mass rallies, sit-ins, marches, or other demonstrations. The college, later becoming Columbus State University in 1996, allowed Columbus to move from an unskilled labor and mill-dependent economy to a commercial powerhouse in a new information age. CSU's interest in revitalizing what had become a stagnant and blighted downtown area has also been extremely significant for Columbus. By revitalizing downtown Columbus, particularly the riverfront area, Columbus was returning to its roots in relying on the Chattahoochee River. By the early 2000s, the downtown area had been completely transformed by a concerted effort from local government, businesses, and other organizations. The new downtown area preserved the old buildings of Columbus's past with loft apartments, fine dining, and other businesses occupying buildings that once housed textile mills, doctor's offices, drugstores, and barbershops. A new Columbus arose, reinventing itself but doing so without discarding its past, earning it the much-deserved motto of a city that progress has preserved.

One
FRONTIER TOWN

In 1828, the City of Columbus was formally established by the Georgia legislature. However, the history of the Columbus area extends much further into the past, as Native Americans called the area home for countless generations. Early pioneers interacted with the natives in the Columbus locale as they traveled between established settlements on the Gulf, such as Mobile and New Orleans, and on the eastern seaboard, such as Savannah. The Federal Road was built in 1806 to facilitate this travel, running just a few miles south of Columbus. The Treaty of Indian Springs ultimately removed the natives in 1825 to lands west of the Mississippi River, making way for the founding of Columbus. For many years, the city was a frontier town at the edge of westward expansion. Growth came quickly for the blossoming town though, and by the 1840s, the city saw a foundation of commerce and industry to position it as one of the leading industrial centers of the South.

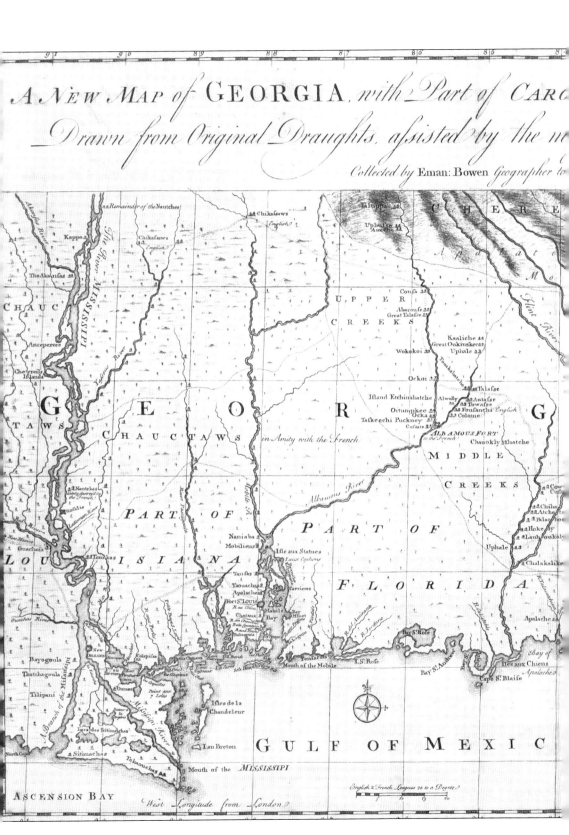

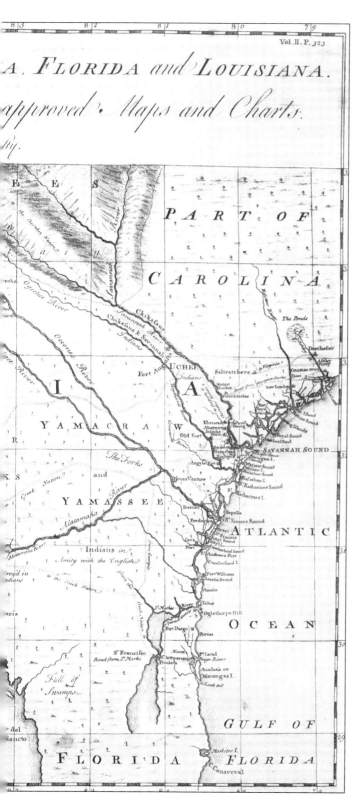

This early Georgia map from 1747 by Emmanuel Bowen depicts the various Native American tribes living in and around the Columbus area. Native American towns in the Columbus area included Coweta and Cusseta. During this time, most of the continent was dangerous and unexplored frontier; cartographers, who were still trying to get a feel for the land, often made mistakes. Of particular interest on this map are the Chattahoochee and Flint Rivers. The Chattahoochee is shortened, while the Flint extends into the Appalachians. This map also represents the political aspects of cartography, as Bowen placed the "G" in Georgia on the other side of the Mississippi—land that France controlled at that time. (Courtesy of J. Kyle Spencer Map Collection, CSU Archives.)

13

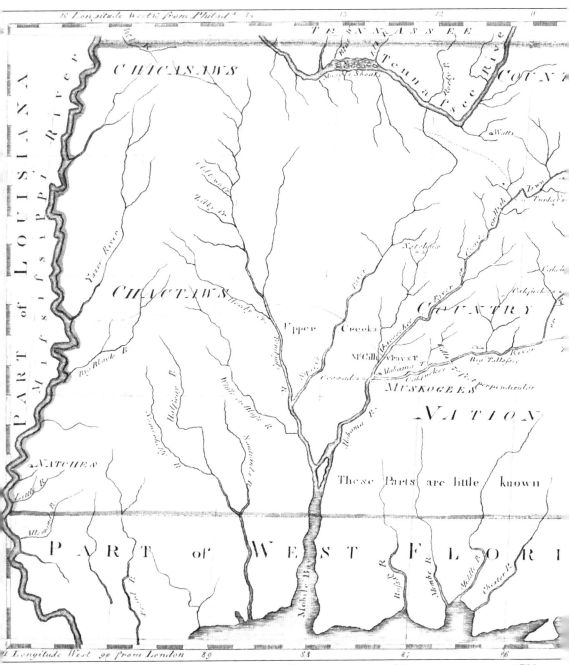

"Georgia from the Latest Authorities" shows the same presence of Native Americans in 1799 as Bowen's 1747 map. However, by this time, there were increasing interactions between the Native Americans and the early pioneers who moved through the Columbus area on the Federal

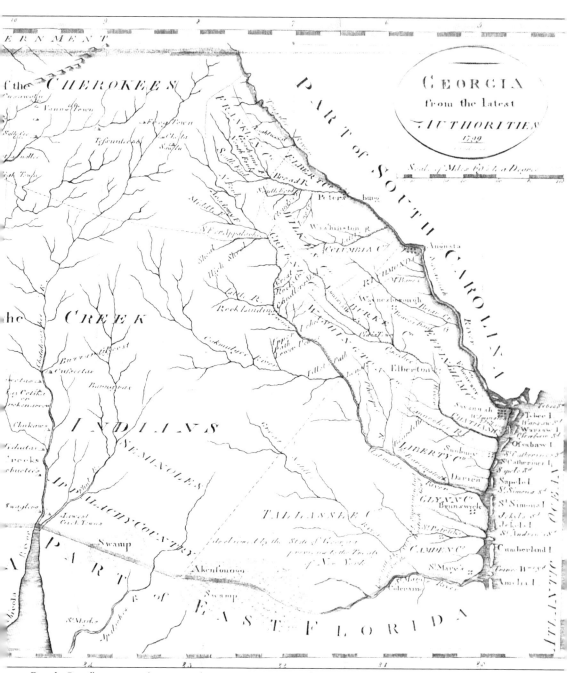

Road. Conflicts arose between these two groups, so the United States built Fort Mitchell on the Alabama side of the river to protect the road. (Courtesy of J. Kyle Spencer Map Collection, CSU Archives.)

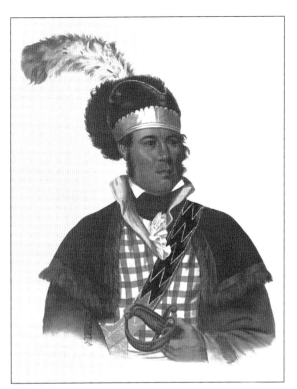

William McIntosh signed the Treaty of Indian Springs in 1825, ceding all land east of the Chattahoochee River to the state of Georgia. McIntosh, son of a British trader and a prominent Creek woman, represented the Lower Creeks, agreeing to move his people to lands west of the Mississippi River.

McIntosh's treaty was not approved by the entire Creek Nation. There were many who disapproved of negotiating with the Americans and viewed McIntosh as a traitor. Menewa led a group of Upper Creeks and ambushed McIntosh at his home. The attackers lit the house on fire, and when McIntosh tried to escape, they shot and killed him, tossing his body back inside the burning house.

This drawing by Basil Hall, titled "Embryo Town," is one of the earliest scenes of Columbus, showing the first homes in the new city. Settlers were so eager to come to Columbus, they built prefabricated housing before the city was properly surveyed. These homes were built to be moveable, as land lots had not yet been auctioned off, so settlers would ultimately need to move to whichever lots they would come to own. (Courtesy of Columbus Museum.)

Dr. Edwin L. de Graffenreid was one of the commissioners responsible for the original plan for Columbus. He is responsible for Columbus's wide streets, as he considered this crucial for good health and sanitation. After working on the layout of the city, he continued living in Columbus and served as physician to the early residents. He cared for Columbus residents and the neighboring Native Americans.

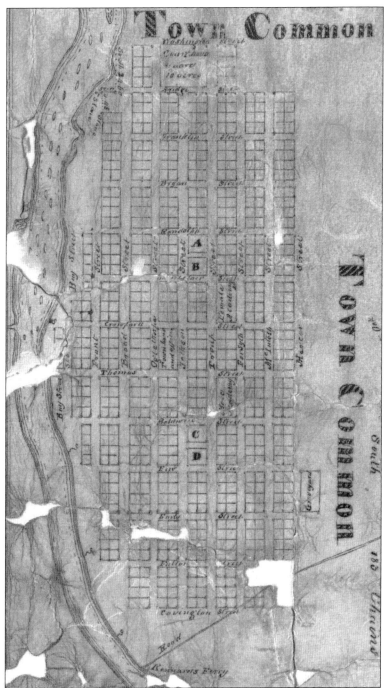

The original survey of Columbus by Edward Lloyd Thomas in 1828 shows the planned layout of the city. There were lots reserved for churches, schools, and government buildings, as well as common areas reserved for citizen activities on the outskirts of town. The courthouse square would later be moved to a more central location in town, making space for a "north commons." The original streets were named for famous Georgians and Americans, but were changed in the late 1880s. (Courtesy of Georgia Archives.)

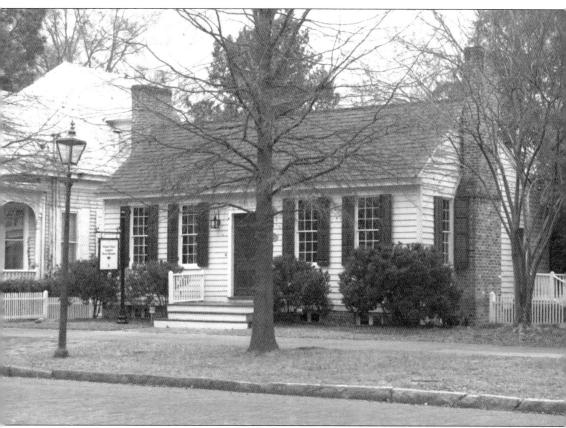

The Walker-Peters-Langdon House, built in 1828, is considered the oldest home in Columbus. It is believed to be one of the original prefabricated homes depicted in Hall's "Embryo Town" drawing. Virgil Walker, who owned a plantation in Harris County, was the original owner of the lot, but it is believed that the Peters family was the first to live in the home. The home exists today much as it did then, with the original siding and windowpanes, for example. (Courtesy of Lisa Roy.)

City Mills, one of the earliest industries in Columbus, was the first factory to take advantage of the Chattahoochee River. Founded in 1828 by Seaborn Jones, it harnessed the power of the river to grind corn and wheat into cornmeal and flour. The mill operated for over 150 years into the late 1980s.

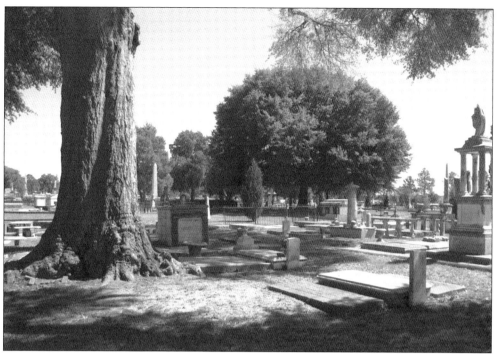

The city cemetery, known as Linwood after 1894, was incorporated into the original city plan by Edward Lloyd Thomas. Thomas's own son was the first interred there in 1828. In the beginning, residents simply chose their ground for burial, but by 1845, a plot system was implemented whereby residents selected and purchased lots. (Courtesy of Jane Brady.)

Slaves were not buried in the official city cemetery. Instead, they were buried at a separate location on the southeast side of town. The original slave cemetery has been lost to time, but a garden and historical marker now commemorate the site.

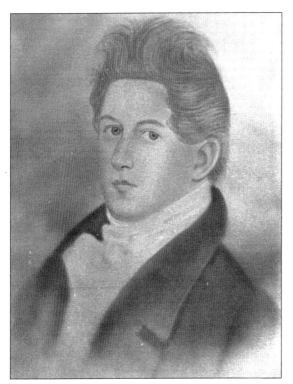

Ulysses Lewis was elected the town's first public official in 1829, serving as intendant, an administrative officer similar to a mayor. An elected government was an important first step to forming a proper city. Lewis and his wife, Sarah Ann Abercrombie, both died in 1856 and are buried in Linwood Cemetery.

Mirabeau B. Lamar was an influential early resident of Columbus. In 1828, he established the *Columbus Enquirer*, which later became the *Columbus Ledger-Enquirer*. In one of Lamar's first news columns, he describes the city, stating, "Our town offers many advantages to the agriculturist who may locate near it, as well as the merchant or mechanic, as our market will afford good prices for all kinds of produce, and our river a safe and convenient navigation on which to export the same. Those who may visit this place with a view of purchasing to settle here, will not leave us disappointed." In 1835, Lamar moved to the Republic of Texas and became its third president.

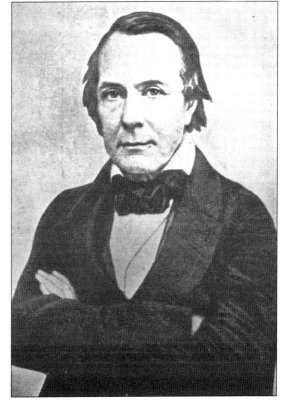

John Fontaine was elected Columbus's first mayor in 1836. Having previously been administered by an intendant, the municipal government was transformed when the state of Georgia elevated Columbus from town to city. Under Fontaine's tenure, Columbus began to look more like a city and less like a frontier town, with street lighting, sewer drains, a new courthouse, and predecessors to city police and fire departments all taking shape during this time.

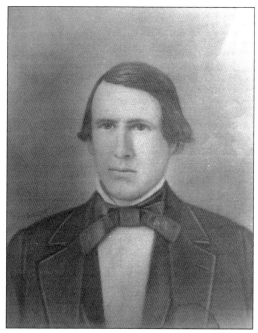

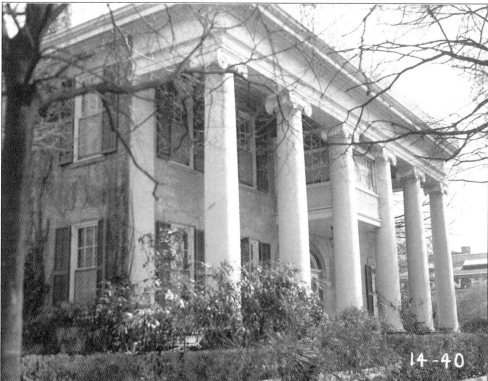

The Fontaine House, built for Mayor John Fontaine, was among the early city's finest homes. It stood on Front Avenue before it was destroyed in the 20th century. While many elites had palatial homes on the riverfront, others lived on First and Second Avenues, and others in the high uptown neighborhoods north of town. (Courtesy of Library of Congress.)

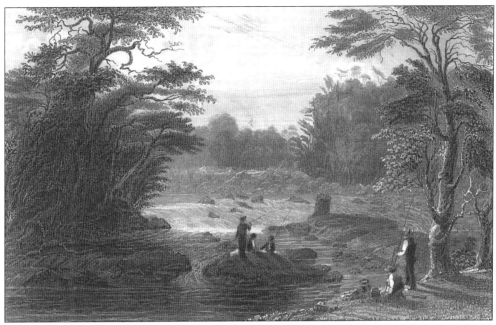

This drawing, done by a visitor in the 1840s, depicts Lovers Leap, a fabled spot where two Native American lovers from separate tribes leapt to their deaths rather than be separated as their respective tribes had ordered. It also illustrates how the Chattahoochee River would have looked before industrial development and the building of the dams. (Courtesy of Columbus Museum.)

This sketch, done by a visitor to Columbus in the 1840s, shows a view of Columbus from the Alabama side of the river. By the late 1840s, downtown Columbus and the riverfront were experiencing considerable growth, as can be seen in the skyline here. (Courtesy of Columbus Museum.)

Two

Antebellum Columbus and the Civil War

As Columbus continued to grow, it transitioned from a frontier town to a well-established city. As residents began to settle down and build new lives for themselves, they built extravagant homes, joined churches, participated in cultural activities, and supported educational institutions. Industries and other businesses experienced great success. Taking advantage of the city's unique position on the Chattahoochee River, they created job opportunities that fueled Columbus's growth. In the mid-1800s, Columbus must have been an exciting place to be. However, there would soon be dramatic changes, as Columbus was flung into the chaos of the Civil War. At first, Columbus benefited greatly from the manufacturing needs of the Confederacy. This was a major boon to the city, but it was also a danger, as it marked the city as a high-priority target for the Union military. Despite its location in the Deep South, battle did ultimately come to the city and had lasting effects. There was also a deeply personal impact. Columbus's sons went off to battle, many never to return, leaving grieving loved ones behind. Houses were also divided, with loyalties split between state and Union.

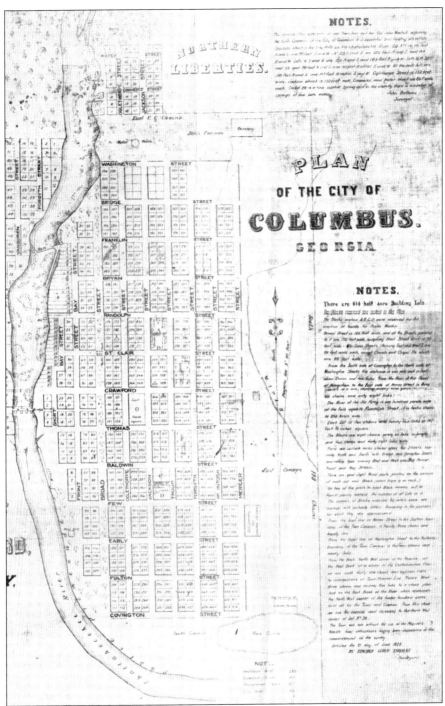

This late 1840s map of Columbus shows the growth of the city compared to the original layout of 1828. The first mills and dams had been built, as well as the churches, schoolhouses, and courthouse, all hallmarks of a well-established city. Columbus's growth was staggering. People recognized the opportunity that Columbus offered and came from many different places, nationally and internationally.

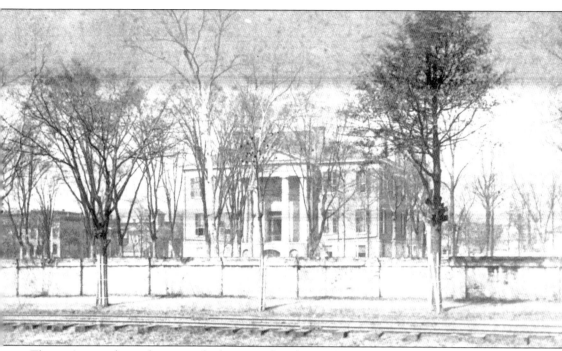

The city's second courthouse was built in 1840 by John Godwin and his slave Horace King, and remained in use until 1895. The first courthouse was a temporary wooden structure never meant to be permanent. The city and county split the construction cost, which was $30,000.

The Methodists were the first to establish a congregation, in 1828, with St. Luke Methodist Church built in 1831. The brick structure pictured above was built in 1846 and replaced in 1897. The 1897 building burned on May 10, 1942, and was replaced by a new building in 1948 (below).

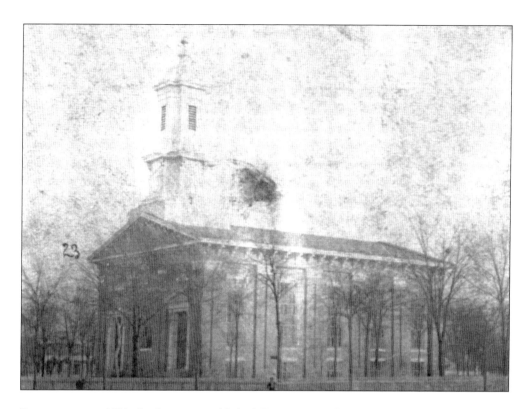

First meeting in 1829, the Baptists established First Baptist Church in 1830. The building seen above was constructed in 1859 and displays the original steeple. The steeple was later removed and a large portico and columns added, as shown in the postcard below. (Above, courtesy of Historic Columbus Foundation.)

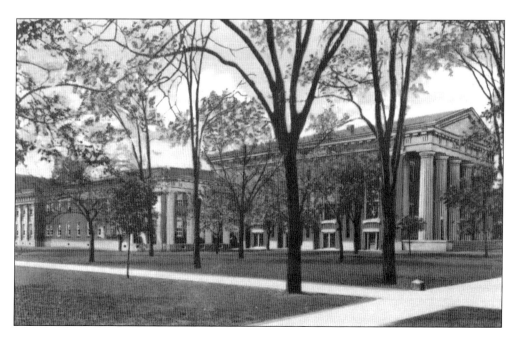

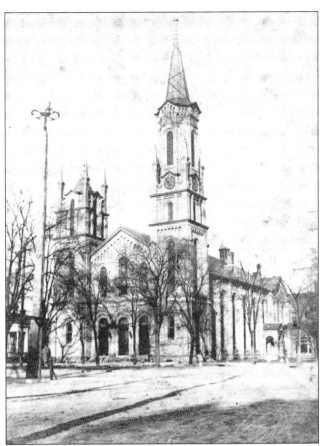

Founded in 1830, First Presbyterian was one of the earliest churches in Columbus. The congregation moved to the building seen here in 1862, on the corner of Eleventh Street and First Avenue. It was rebuilt, although with little changes, after a fire in 1891.

There was a Catholic presence in the city as early as 1834, due in large part to Irish immigrants. The original congregation, known as the Church of St. Philip and St. James, was renamed the Church of the Holy Family when a new church was built in 1880, pictured here. Designed by Daniel Matthew Foley, it features Gothic and Byzantine architecture.

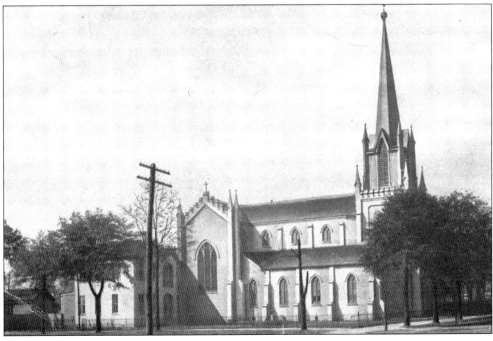

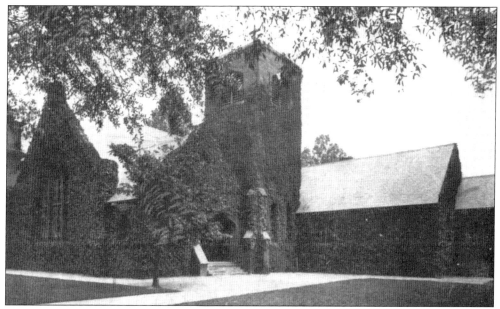

Trinity Episcopal Church was established in 1834; it was the fifth Episcopal church in Georgia. The congregation's second building was erected in 1890 at 1130 First Avenue. The congregation moved there from its original location at 1140 First Avenue. This photograph is from the early 1900s, before the parish house was built in 1925.

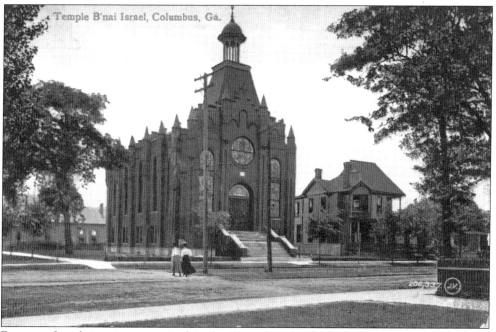

European Jewish immigrants arrived in the Chattahoochee Valley as early as the 1830s, but a physical synagogue was not constructed until after the Civil War. Seen here is Temple Israel at its original downtown location. This building was later destroyed, with the congregation relocating to a new site on Wildwood Avenue in 1951. (Courtesy of Historic Columbus Foundation.)

Splitting from the white First Baptist Church, former slaves established First African Baptist Church in the 1860s. The congregation moved to the corner of Eleventh Street and Sixth Avenue in 1915, into the building seen here. It is the oldest African American congregation in Columbus. (Courtesy of Lisa Roy.)

St. James AME was organized in 1863, with the building finished in 1873. It is the second oldest AME church in Georgia. (Courtesy of Lisa Roy.)

Born in the Wynnton area of Columbus in 1835, Augusta Jane Evans was a prominent Southern author. Her work is known for its intimate look at Southern culture and society, as well as its strong and intelligent female characters. She was also a fierce Southern patriot supporting the Confederacy through her literature, but also in other ways, such as attending to wounded soldiers. (Courtesy of Columbus Museum.)

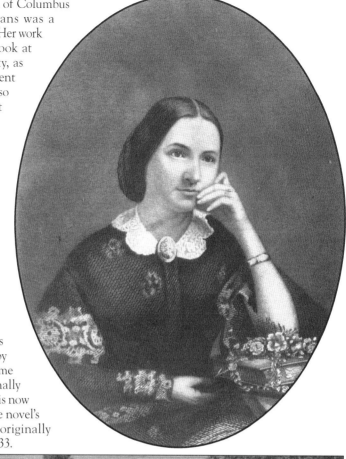

Augusta Evans's most famous novel, *St. Elmo*, was inspired by the time she spent at the home of her aunt and uncle. Originally named El Dorado, the home is now known as St. Elmo due to the novel's popularity. The house was originally built by Seaborn Jones in 1833.

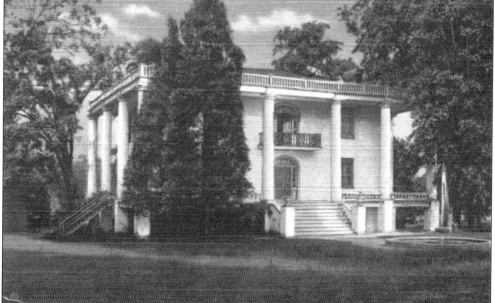

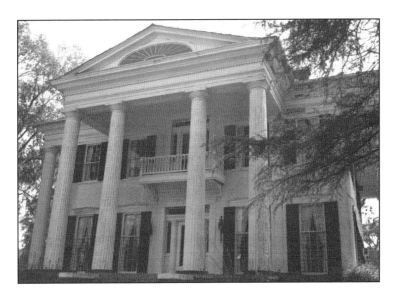

Originally called Oakview, the Wynn House was built in 1839 for Col. William Wynn. The home was originally a plantation home on over 100 acres. Its Greek Revival style, popular with planters, features massive Doric columns, a widow's walk, and cupola.

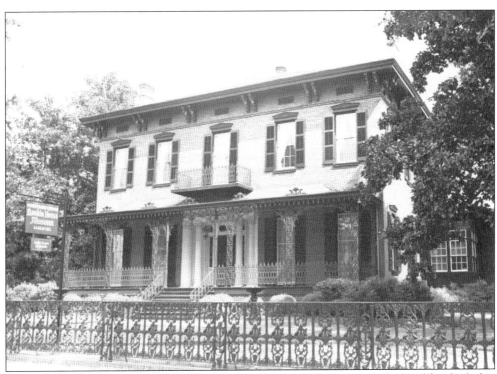

Construction began on the Rankin House prior to the Civil War but was halted and finished after the war. One of its most noted features is the intricate iron grillwork on the balcony and lower veranda. James Rankin, for whom the house was built, was a planter originally from Scotland. He was also the owner of the Rankin Hotel.

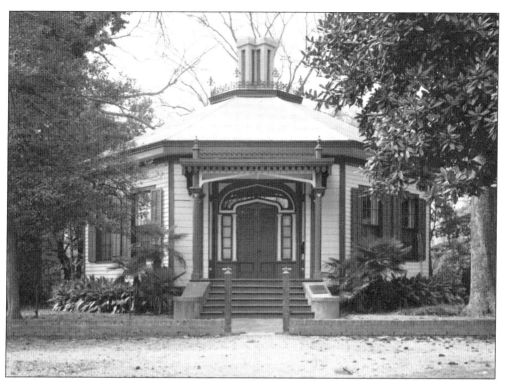

The Octagon House, also known as "the Folly," is one of the most unusual homes in Columbus. The original structure, built in the 1830s, was bought and modified by cabinetmaker Leander May, who gave it its unique octagon shape. (Courtesy Library of Congress.)

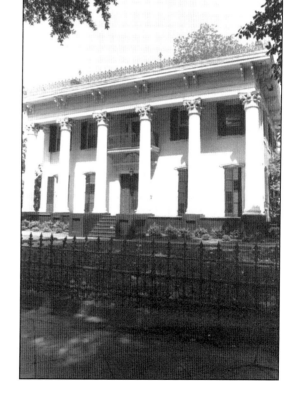

James A. Chapman built the Illges House in 1850. Its 20-foot-high Corinthian columns feature ornate detailing. Abraham Illges bought the house in 1877, adding a brick extension to the rear of the house and a wrought-iron fence that echoes the original elegant wrought-iron detailing of the house.

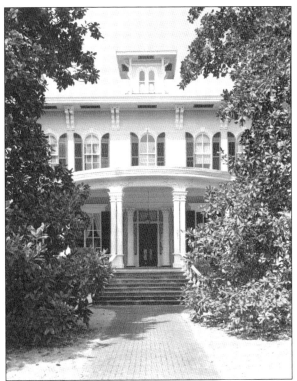

Dinglewood has long been considered one of the finest homes in Columbus. Built in 1858 in an Italianate Villa style, the home's first residents were the Hurt family. Julia Hurt, after losing her husband, Capt. Peyton Colquitt, in the Civil War, lived in Paris, France, where she was courted by the emperor's great-grandnephew Jerome Napoleon Bonaparte. Afraid of being caught up in court intrigue and political affairs, she refused his hand in marriage. (Courtesy of Library of Congress.)

In the area of Rose Hill stood the Redd House, constructed in 1859 for Albert Gresham Redd. The home's Gothic architecture is reminiscent of Old World Europe. It was destroyed in the 20th century. (Courtesy of Library of Congress.)

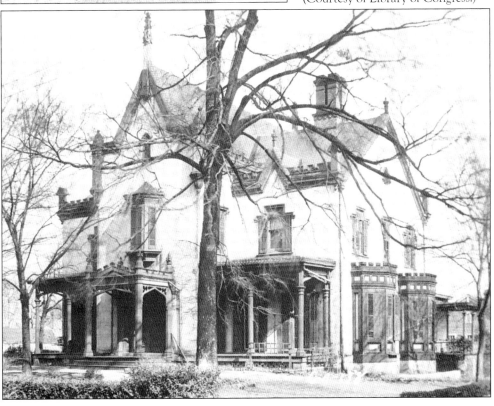

NEGROES! NEGROES!!

WE are continually receiving from Virginia and North Carolina a large and well selected stock of Men, Women, Boys and Girls, including Field Hands, House Servants, Mechanics, &c., bought by one of the firm expressly for this market, and our friends may rely on getting negroes of good character, coming up fully to our representations—as we sell none on commission.

HATCHER & McGEHEE.

July 27, 1858 w tf

The Hatcher and McGehee Company was one of several firms selling slaves in Columbus. Slaves were auctioned off at the slave market on Broadway. As seen here, new shipments of slaves were regularly advertised in the local newspaper.

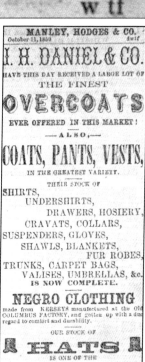

Many businesses marketed to slave owners, selling products specifically for slaves. Slaves normally received clothes only once a year, and they were often cheaply made and from rough material. This newspaper advertisement from 1859 showcases the wares of J.H. Daniel & Co., which was located at 123 Broad Street.

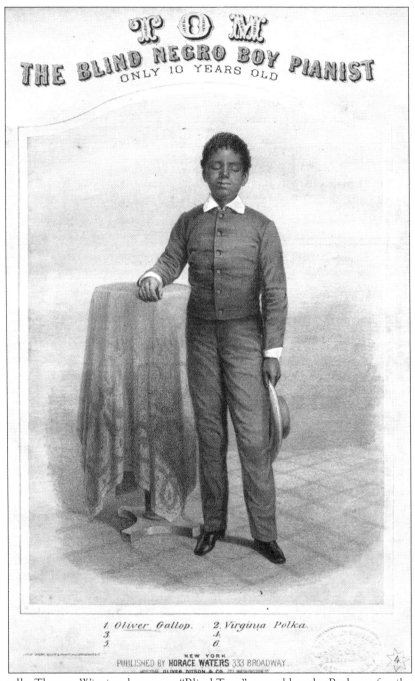

Born locally, Thomas Wiggins, known as "Blind Tom," was sold to the Bethune family at a very young age. Due to his blindness, instead of working in the fields, he became a house servant. His owner quickly discovered Wiggins's musical abilities and aptitude for the piano and set out to exploit his talent. They toured the nation, making Blind Tom a national sensation. After the Civil War, the Bethune family maintained custody, having the courts declare Wiggins mentally disabled and unable to care for himself. The Bethunes continued taking advantage of Blind Tom, and because of this, he is often called "the last American slave."

Horace King, a slave originally from South Carolina, came to Columbus in 1832 with his master, John Godwin, a master craftsman and builder who shared his knowledge with King. Together, they are responsible for many of the city's earliest structures. Godwin freed King in 1848, after which they continued working together.

Horace King is best known as a bridge builder. He, along with John Godwin, built the first bridge between Columbus and neighboring Girard, Alabama (now Phenix City). After the Dillingham Street Bridge was burned in the Battle of Columbus, King rebuilt the bridge in the 1860s with the one seen here. King's work was not limited to Columbus; his bridges and other examples of his workmanship can be found all across the southeast.

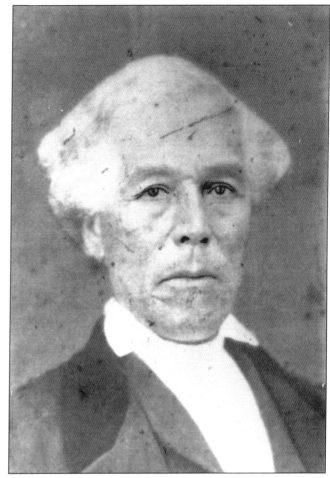

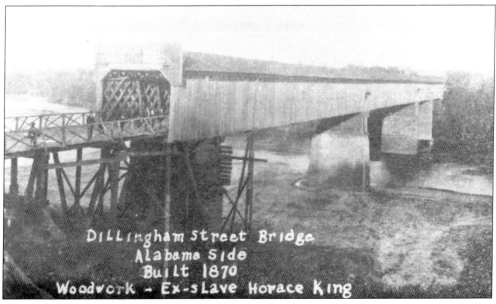

Dillingham Street Bridge
Alabama Side
Built 1870
Woodwork - Ex-slave Horace King

Clapp's Factory, the first textile mill in Columbus, was located on the northern outskirts of Columbus and began operations in 1838. In the beginning, it manufactured yarn but later expanded its operation to include a gristmill, sawmill, leather tannery, and shoe factory. The mill was burned during the Civil War but was rebuilt by Horace King. It closed in the 1880s, and the abandoned mill burned again in 1910.

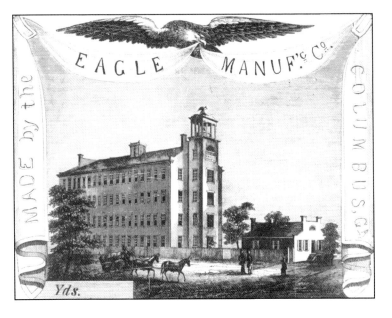

Founded in 1850 by William Young, the Eagle Mill became one of the largest and most successful mills in the South. The Eagle Mill ran 24 hours a day in two 12-hour shifts during the Civil War producing material for uniforms and tents. This label depicts the mill as it looked before Union forces burned it in 1865. (Courtesy of Library of Congress.)

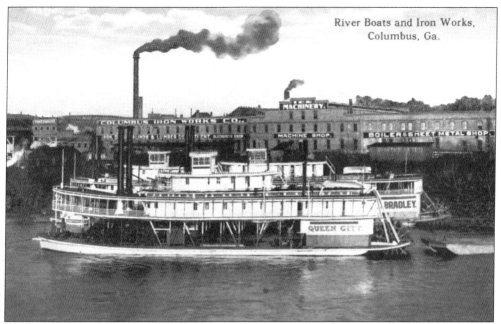

The Columbus Iron Works, established in 1853 by William Brown, supplied the area with a variety of manufactured goods such as kettles, ovens, fittings, and machinery for the mills. During the Civil War, it manufactured cannons, mortars, and parts such as boilers for Confederate Navy vessels. After the war, the business found great success manufacturing steamboat parts and ice machines.

Prussian immigrants who came to Columbus in the 1800s started Haiman's Sword Factory at the corner of First Avenue and Fourteenth Street. The business was one of the leading industries of its kind in the Confederacy. At one point, Haiman's employed over 400 people, producing over 250 swords a day. This detail shot shows the exquisite craftsmanship of Haiman's etching work. (Courtesy of Columbus Museum.)

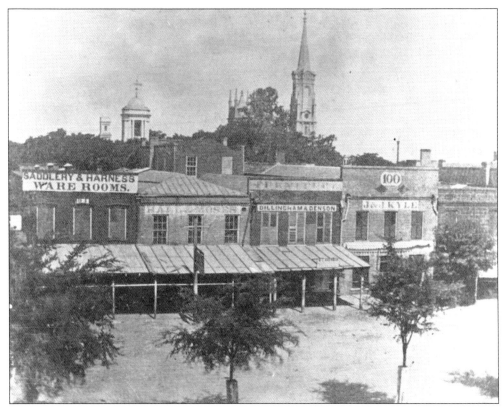

Columbus was a bustling city by the 1860s. It was one of the Confederacy's largest production centers during the war, and a major target for Union forces seeking to put an end to the South's ability to wage war. Here, the steeple of First Presbyterian dominates the Columbus skyline.

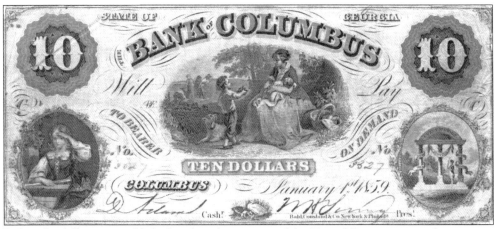

Before the dollar was established as the sole currency of the United States, states and sometimes towns issued their own currency. The Bank of Columbus was established in 1856, later becoming the First National Bank of Columbus. It issued its own currency such as this $10 bill.

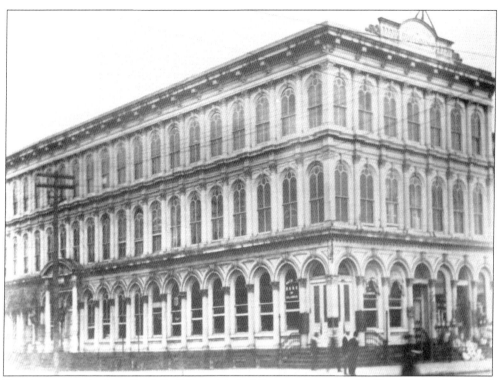

Now known as the Iron Bank Building, this building was home to the First National Bank of Columbus and was called the Iron Bank because of its cast-iron facade. Construction was ongoing during the Civil War, with locals hiding the cast iron pieces so they would not be melted down. Before being home to the bank, it was originally home to the Georgia Home Insurance Company.

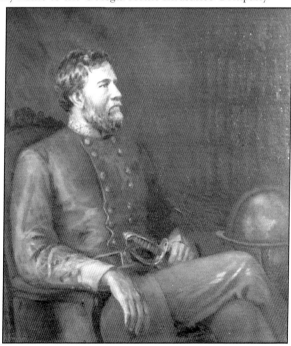

Gen. Henry Benning, for whom Fort Benning is named, practiced law in Columbus prior to the Civil War. He also served on the Georgia Supreme Court. After Georgia seceded from the Union, he joined the Confederate military serving under Robert E. Lee. He earned the nickname "Old Rock" due to his unwavering courage in the Battle of Antietam. After the war, he returned to Columbus, where he died in 1875.

The Nuckolls family of Columbus had three sons who fought in the Civil War. Two of them died, leaving Thomas the only son. Louisiana, a heartbroken mother, wrote her only surviving son this tear-stained letter telling him the news of the latest death. The letter begins with, "Thomas, my lone son how shall I, how can I begin to write to you when it's almost torture to my poor broken heart to think much less speak of and write to you about our dear lost yes murdered child."

James Howard, originally from Tennessee, fought for the Confederacy in the Civil War. He was wounded near Resaca, Georgia, in May 1864 and hospitalized in Columbus, where he met his future wife, Jane Hendrix. After the war, he returned to Columbus to live, marrying Jane and having four children.

Robert Archelaus Hardaway, born in 1829, was an artillery officer during the Civil War. His battlefield diary gives amazing details of his time during the war. He often included sketches of the battles, including this one depicting a deployment of artillery. His son, Robert Early Hardaway Sr., settled in Columbus and led the Hardaway Company to be a top construction and development firm across the southeast.

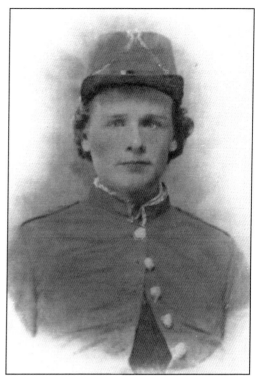

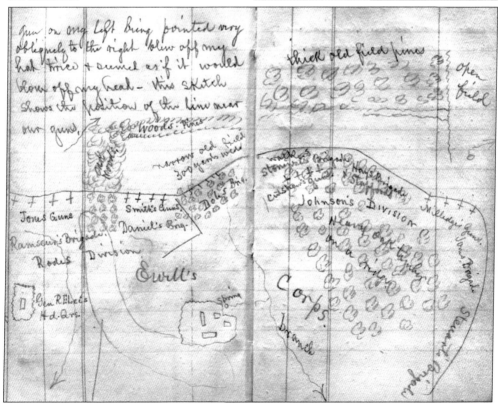

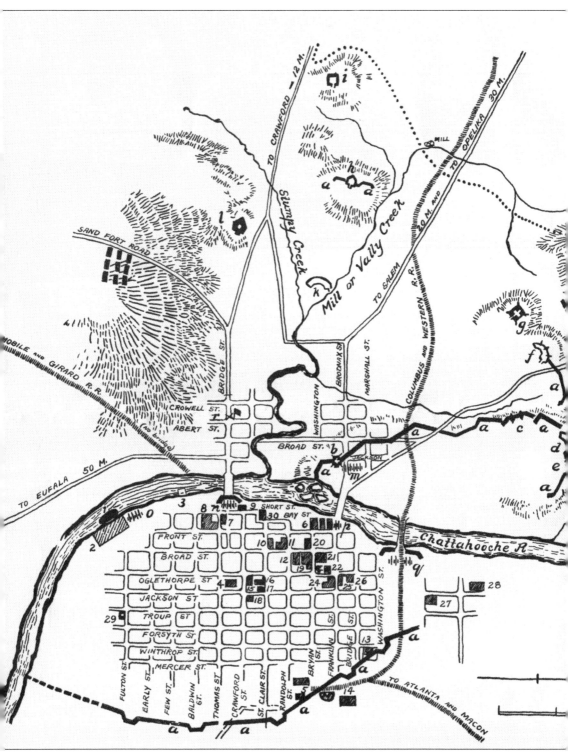

This map of the Battle of Columbus shows Union troop placement and Confederate defensive fortifications. The battle took place on Easter Sunday, April 16, 1865, and lasted only one day.

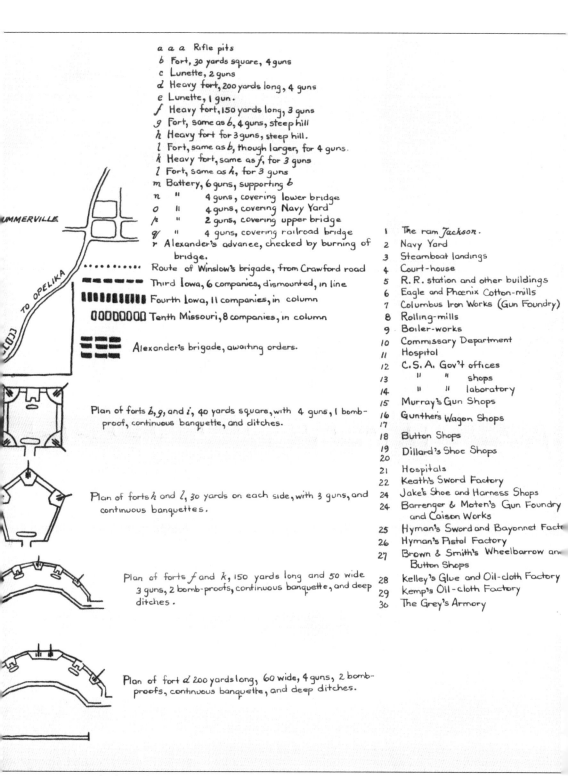

Happening only days after Lee's surrender at Appomattox on April 9, it is often called the last battle of the Civil War.

Confederate general Howell Cobb, a career lawyer and politician, came to Columbus in the spring of 1865 to lead the city's defense. He escaped the Battle of Columbus only to surrender in Macon, Georgia, a few days later on April 20. He died after the war in 1868 from a heart attack. (Courtesy of Library Congress.)

Union general James H. Wilson from Illinois led the attack on Columbus with the third and fourth Iowa Cavalry. His daring attack led to a quick victory. After the battle, his troops burned any industry that could support the Confederate cause. He later remarked, "Had we but known what had taken place in Virginia . . . we should certainly not have . . . participated in the injury which was inflicted upon [Columbus'] industries." (Courtesy Library of Congress.)

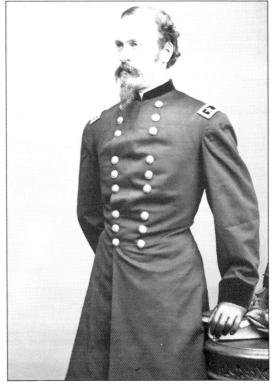

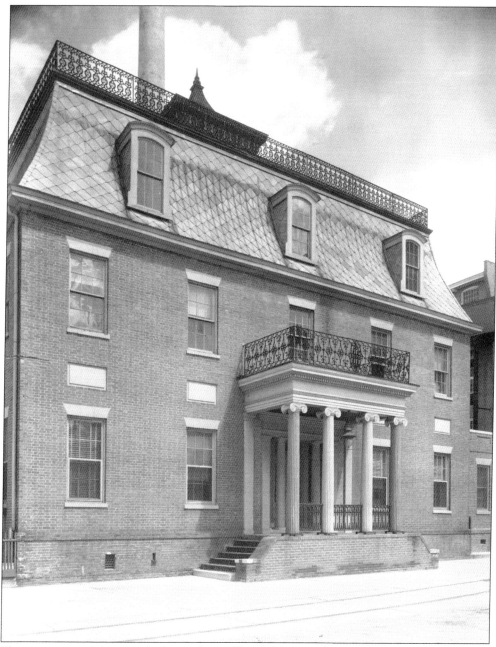

The most intense fighting took place in front of Randolph Mott's house. The Mott House is known as the house that never left the Union, as Mott was a staunch Unionist who reportedly flew the Union flag daily inside the house's cupola. Mott's house served as Wilson's headquarters while he was in Columbus. Mott's son, John Mott, did not agree with his father's loyalties. Instead, he joined the Confederate military and served as Gen. Henry Benning's adjutant. Despite Randolph Mott's Union loyalties, he was a well-respected citizen of Columbus. During the war, his factories even supported Confederate troops. After the war, he continued to be heavily involved in business and civic affairs, including serving as mayor pro tem. He died in a tragic train accident in July 1881 and is buried in Linwood Cemetery. (Courtesy of Library of Congress.)

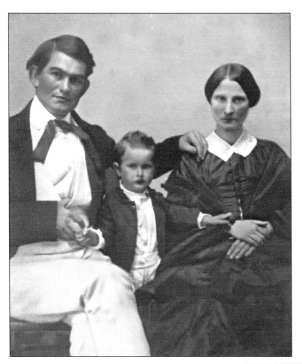

John Pemberton, the inventor of Coca-Cola, was a pharmacist who moved to Columbus in the 1850s. He suffered from chronic intestinal pain, resulting in morphine addiction and his search for a replacement painkiller. He fought in the Battle of Columbus for the Confederacy and suffered a saber wound, which further spurred his quest to find a morphine replacement. (Courtesy of Historic Columbus Foundation.)

There is some evidence suggesting Pemberton developed the original recipe for Coca-Cola while in Columbus, later taking it with him to Atlanta. As a druggist in Columbus, he offered many different remedies for the local citizenry. This newspaper advertisement promotes his drugstore on March 2, 1860.

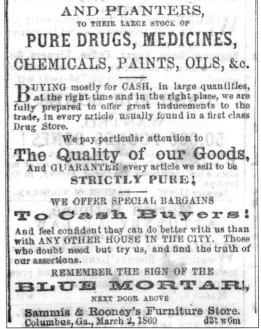

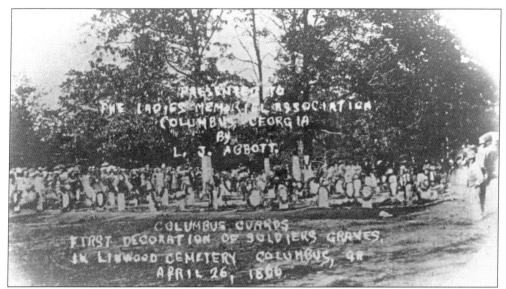

Lizzie Rutherford and Mary Williams, along with the Ladies Memorial Association, may have been the originators of the national observance of Memorial Day with this first ceremony on April 26, 1866. They called for an annual decoration of all fallen soldier's graves and wrote to others across the nation to make this a national occurrence. A federal decree was issued recognizing the official Memorial Day to take place in late May, as flowers were not yet in bloom in the northern states in April.

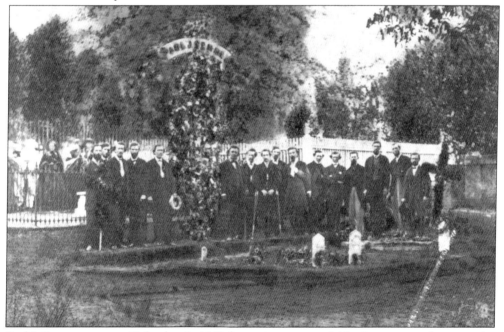

Paul J. Semmes came to Columbus in 1840, becoming a successful businessman and community leader. He joined the Confederate military at the start of the war and, by 1862, was promoted to brigadier general. He participated in numerous battles including Gettysburg, where he was mortally wounded. His body was returned to Columbus after the war and buried in Linwood Cemetery. His comrades, many showing battle wounds, attend his funeral in this photograph.

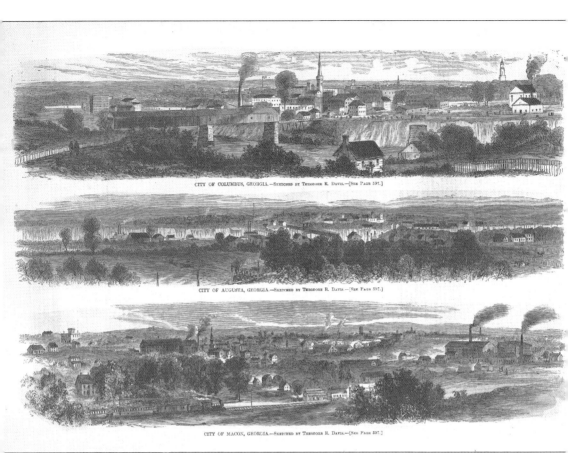

By 1868, with wounds healing, Columbus was on the road to recovery in the aftermath of the Civil War and would soon again be an economic powerhouse. This 1868 illustration from *Harper's Weekly* shows that the covered bridge and the mills, which had been burned, had by now been rebuilt. It also places Columbus among the leading cities in Georgia alongside Augusta and Macon. (Courtesy of Columbus Museum.)

Three
Mill Town

Industry in Columbus was devastated in the aftermath of the Civil War. However, Columbus quickly rebounded and would again be an industrial giant, not only in the South, but also in the United States as a whole. The textile industry in particular boomed in the late 19th and early 20th century. The Eagle and Phenix and Bibb Mills were perhaps the most significant, with both often described as among the largest mills in the world. The Bibb claimed to be the longest mill and the Eagle and Phenix claimed to have more spindles than any other mill. The presence of the mills in Columbus was so massive that they earned the city the name "Lowell of the South" after the major textile center in Lowell, Massachusetts. The mills were not the only industries in the city, however. Columbus had a diverse manufacturing sector and a broad range of other businesses that complemented the textile industry. Supported by its industrial success, the rest of the city grew as well. New shopping destinations and opportunities for leisure, entertainment, and cultural activities all increased. A focus on public welfare also drove city improvements, including new schools, a new courthouse, and the first public library, to name just a few.

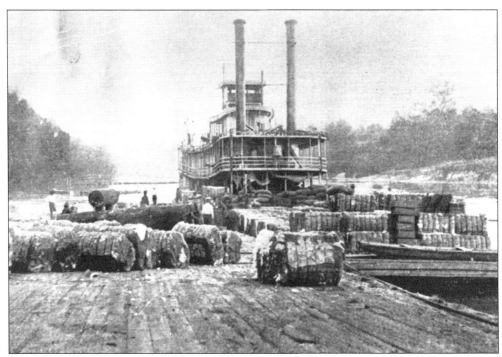

Cotton was king in the South and it remained dominant even after the Civil War. Columbus was a major destination for cotton crops heading out to global destinations via the Chattahoochee River. Workers in this photograph are loading a steamboat at the Columbus docks.

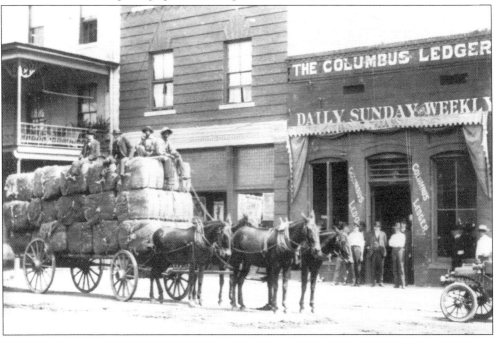

Even in the 20th century, cotton was a staple of life in Columbus. In this c. 1905 photograph, a wagon of cotton is headed to market, most likely destined for the steamboats of the Chattahoochee, which operated regularly into the 20th century.

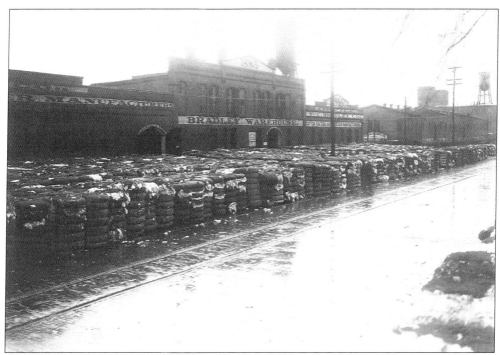

Cotton brought into the city was stored in massive warehouses, where it waited for steamboat transportation or delivery to the local textile mills. In this photograph, bales of cotton line the street in front of the W.C. Bradley Co. This particular cotton warehouse was built in 1895. (Courtesy of W.C. Bradley Co. Archives.)

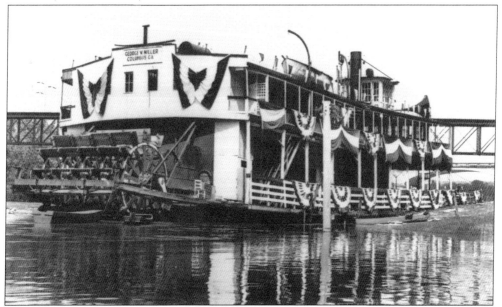

Even after the days of steamboat commerce, the river boats remained important to Columbus, as residents and tourists vacationed and traveled for pleasure on them. The *George W. Miller*, seen here, originally built in 1926, operated as a trading vessel on the Mississippi. It was later moved to the Chattahoochee, where it operated as an excursion vessel.

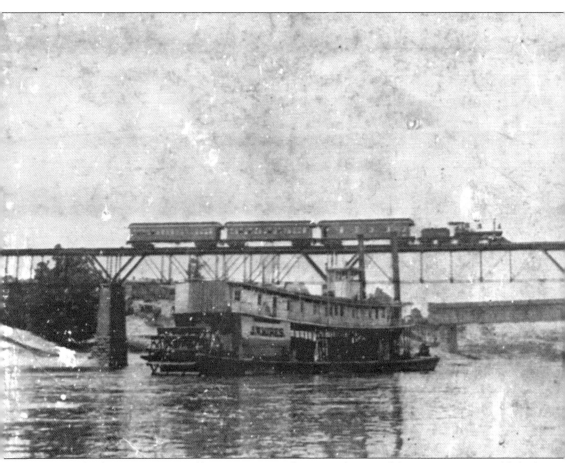

As Columbus grew, major rail lines connecting the city to the rest of the country were established. The railroad first came to Columbus in the 1850s. The city invested heavily in building more rail lines and, by the turn of the 20th century, was connected to much of the Southeast. The Mobile & Girard Railroad line is pictured here along with the old Columbus mainstay, steamboat transportation. Despite the advances of the railroad, it did not negatively affect trade on the river. Steamboat trade flourished in the late 1880s and 1890s. The Steamer J.W. Hires in the foreground was built in Columbus in 1898 and made regular trips from Columbus to the Gulf Coast. A covered Dillingham Street Bridge can be seen in the background.

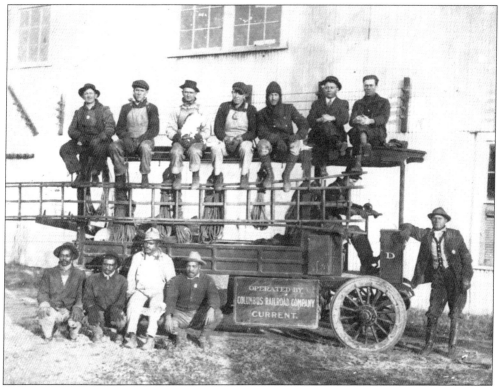

This 1913 photograph shows a crew working for the Columbus Railroad Company. The railroads were a major catalyst for industrial growth and economic development, increasing trade between Columbus and the rest of the country.

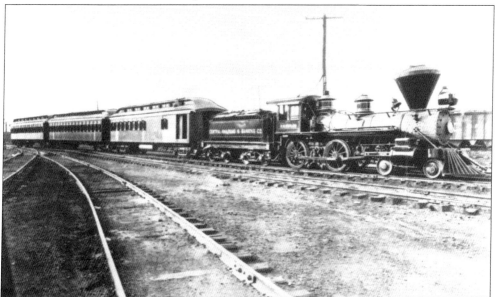

Railroads not only transported goods, they also transported people, bringing visitors into the city and allowing Columbus residents to travel as well. This passenger train belonged to the Central Railroad and Banking Company of Georgia.

"THE LOWELL OF THE SOUTH"
(COLUMBUS, GEORGIA) Population, City and Suburbs, 40,000

4 Cotton and Woolen Mills; 2 large Clothing Manufacturing Establishments; 3 Cotton Compresses; 3 Cotton-seed Oil Mi ron Foundries; 4 Ice Factories; 4 Hosiery Mills; 1 very extensive Wagon Factory; 1 Buggy Factory; 3 Candy Factories rup Refineries; 7 very large Brick Plants; and numerous other minor industries incident to a manufacturing centre. Total weekly pay roll of these industries is between $60,000 and $75,000. Total number of employees, 10,000.

YOUNG ADVERTISING SERVICE---Bill Posters.

This c. 1890s promotional image boasts of Columbus's many industries. Columbus was home to a diverse manufacturing sector and was home to much more than just the textile mills. The textile mills were the major players though, with the name "Lowell of the South" prominently displayed on this postcard. (Courtesy of Historic Columbus Foundation.)

Columbus was home to one of the first mass produced industrial ice machines. It set new standards helping to revolutionize the industry, and was perhaps one of the most successful, sold to broad national and international markets. It was developed by H.D. Stratton in the 1880s and produced by the Columbus Iron Works.

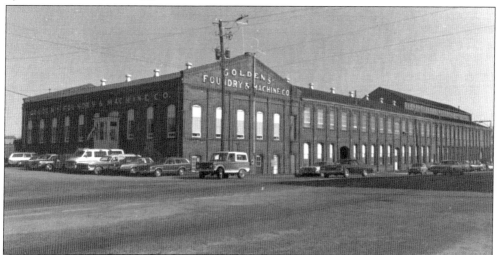

Theodore and John Golden founded Golden's Foundry in 1882. They expanded in 1889 with the help of local businessman Abraham Illges, ultimately taking up an entire city block. It is the oldest continuously operated foundry in Columbus.

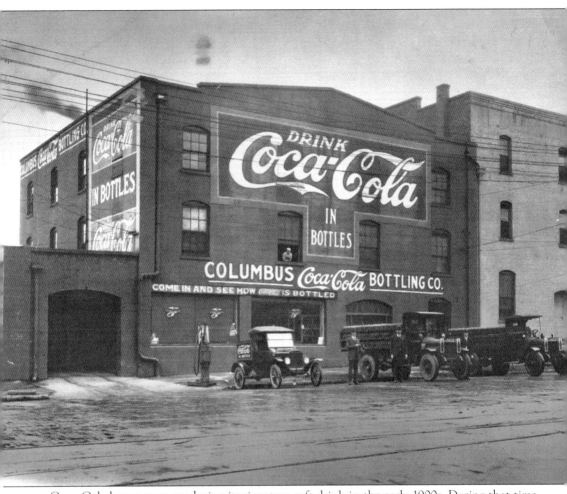

Coca-Cola began mass-producing its signature soft drink in the early 1900s. During that time, Columbus Roberts opened a bottling plant in Columbus on Sixth Avenue between Twelfth and Eleventh Streets. In 1919, a group of Columbus natives, including Ernest Woodruff and W.C. Bradley, purchased the controlling interest in Coca-Cola, beginning a long legacy of involvement. In 1923, Ernest's son Robert Woodruff became Coca-Cola's president. Robert would continue to hold important leadership positions in the company for over 60 years, leading it to new heights and international renown. W.C. Bradley was also prominently involved, serving as chairman of the board in the 1930s and remaining active on the board until his death in 1947. Profits from Coca-Cola's success flowed back to Columbus, fueling further business investments and philanthropic endeavors.

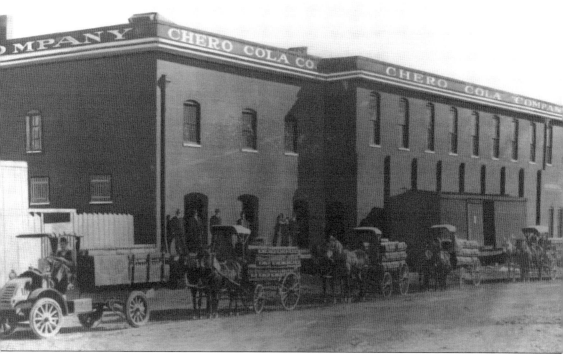

In 1905, Claud Hatcher, a local grocer, refused to pay the high prices of Coca-Cola and created his own alternative: Royal Crown Cola. The company was renamed Chero-Cola in 1910 and again in 1925 as Nehi, in response to the popularity of its line of fruit-flavored drinks. The company returned to its roots in the 1960s, changing its name to Royal Crown Cola Company. Throughout its history, RC has been a leading innovator in the soda industry. In 1951, it became the first national soda company to use cans and later introduced the first all-aluminum can in 1964. The company also created the first caffeine-free soda, RC 100, in 1980. One of its biggest achievements though is perhaps Diet Rite. In a market where all previous attempts at diet sodas had flopped, Diet Rite became the fourth-bestselling soda shortly after its introduction in 1962.

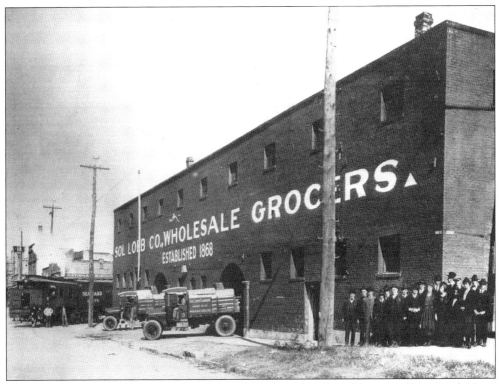

The Sol Loeb Company was founded in 1868 by Solomon Loeb and his sister Betty Loeb Kern. The business began as a liquor and tobacco seller, but after Prohibition, it became a grocery wholesaler and distributer.

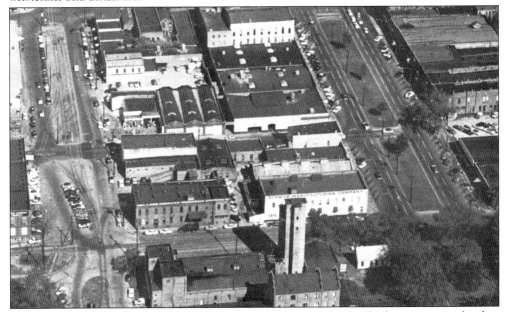

Simon Schwob founded Schwob Manufacturing Company in 1912. The business specialized in producing men's clothing. Simon Schwob and his wife, Ruth, were both active in civic affairs in the community and were major philanthropists, forming the Simon Schwob Foundation.

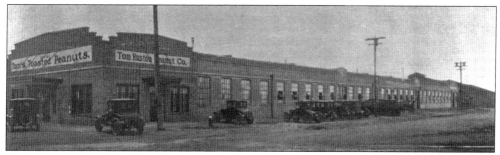

Tom Huston founded the Tom Huston Peanut Company in 1925. Huston's mechanical ingenuity led to him inventing a peanut sheller and peanut roaster that catapulted his product across the nation. In 1930, he was featured in *Time* magazine as "The Farmer Boy who Became Peanut King."

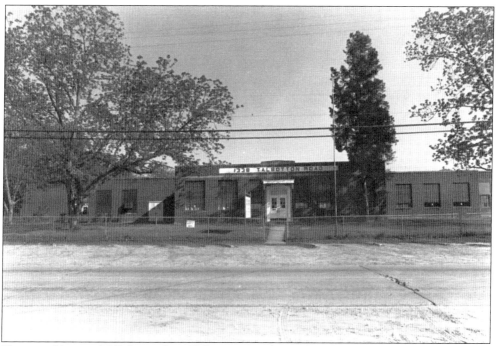

Shannon Hosiery Mill, located on Talbotton Road, was founded in 1938 and produced silk hosiery. It closed in the mid-1950s, but the building was reopened in 1958 as the inaugural site of Columbus College. By the 1980s, Columbus College had moved to a new location, and the building was demolished, making room for a new school, Hannan Academy.

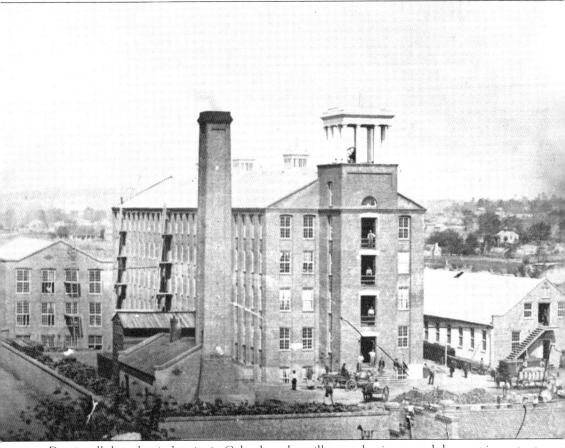

Despite all the other industries in Columbus, the mills were dominant, and the most important mill was the Eagle and Phenix. Union forces burned the original Eagle Mill in 1865. It was rebuilt and resumed operations in 1868, taking on a new name, the Eagle and Phenix, to signify its rebirth from the ashes.

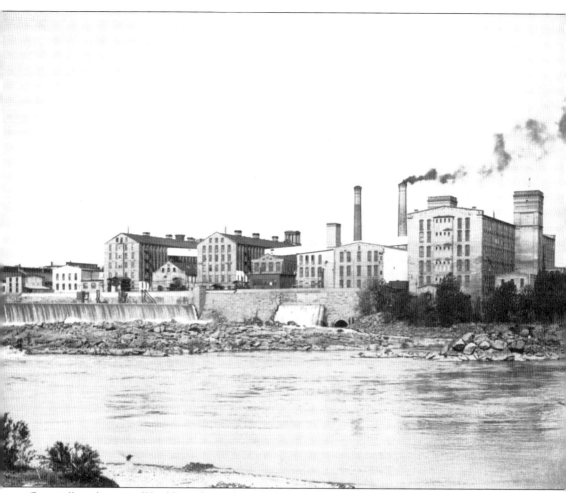

Originally only one mill building, the Eagle and Phenix Mills expanded into a mammoth operation that dominated the river front. The second mill building was built in 1871, and the third followed in 1878. In just 10 years, the mill had tripled its size. It was the largest cotton mill in the South, producing over 110 varieties of goods.

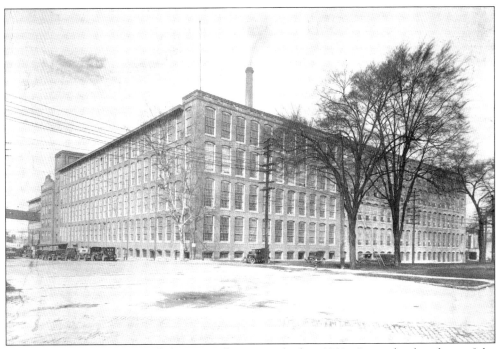

Muscogee Manufacturing Mills began production in the late 1860s. It was developed out of the Coweta Falls Factory, which was founded in 1844, and was one of the earliest textile mills in Columbus. It later became one of the largest mill operations in Columbus.

After George Parker Swift invested in Muscogee Manufacturing, it saw a period of intense growth with six new mill buildings constructed from 1880 to 1950. Numerous other annexes supported growth as well, such as the Mott House and the Carnegie Public Library. The Mott House housed corporate offices, while the library was converted into a machine shop.

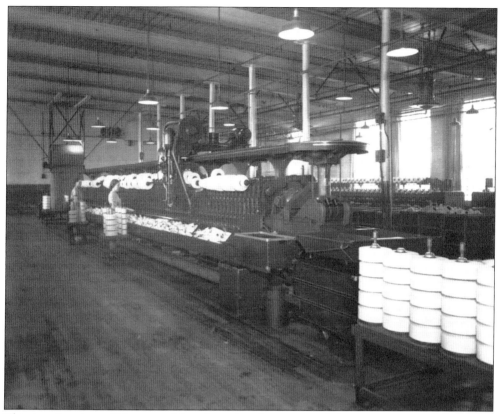
This interior view of Muscogee Manufacturing shows some of the equipment used for textile manufacturing.

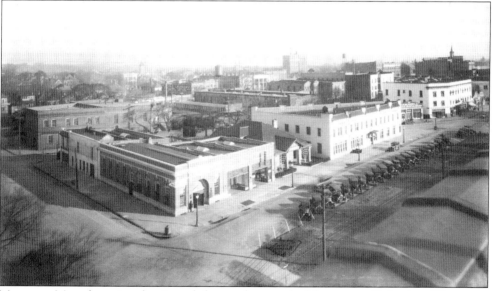
Muscogee Manufacturing dominated the northern end of downtown Columbus. The many workers employed by the mill greatly stimulated that area. This photograph shows the area from the mill building on Fourteenth Street.

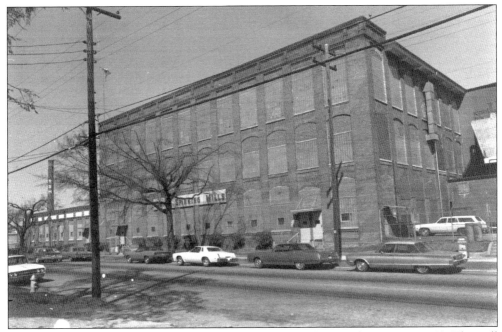

Originally established in 1882, Excelsior Mills became Swift Manufacturing in 1883. The mill originally began in Temperance Hall, located on First Avenue. Temperance Hall was a multipurpose building throughout Columbus's history serving as an entertainment venue, Confederate hospital, and schoolhouse.

In 1967, Swift Manufacturing became Swift Textiles. In 1998, the name changed again to Swift Denim. The company was once a leading supplier of denim but has since declined with the closing of both the original plant on Sixth Avenue, seen here, and a newer plant built in 1980.

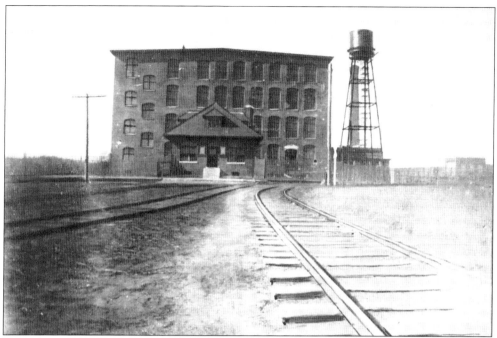

Columbus Manufacturing was established in 1899 and officially began operation on July 4, 1901. It was founded in part to take advantage of the excess power that the Bibb Mill dam was generating. It produced too much power for Bibb to consume alone, so Bibb sold the power to other companies. (Courtesy of Library of Congress.)

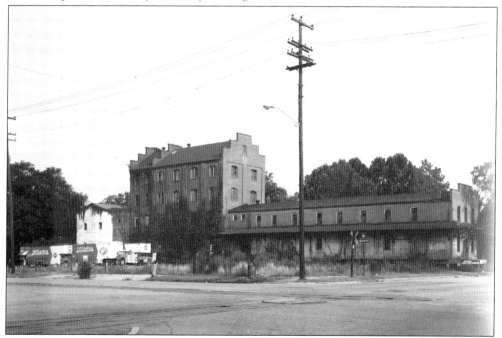

By 1887, Empire Mills was the largest meal and flour mill in the South. It first began operation in 1861 and was a major producer for the Confederacy. It was not considered a wartime factory since it produced food. Thus, it was spared. (Courtesy of Library of Congress.)

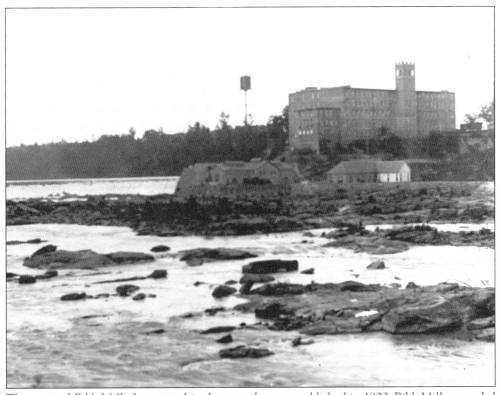

The original Bibb Mill, shown in this photograph, was established in 1900. Bibb Mill expanded rapidly and by 1920 had tripled in size, making it the largest mill operation under one roof, totaling 1,010 feet long. It ultimately surpassed the Eagle and Phenix Mills in size.

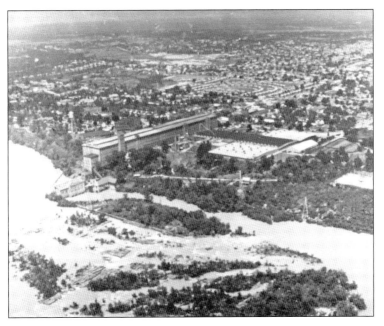

Next to the Bibb Mill was Bibb City, a planned community for the mill workers. In the beginning there were 101 houses, but by the 1930s, they had tripled to over 300. In addition to housing, the mill provided for the workers in nearly all aspects of daily life, including education, entertainment, and leisure activities.

The Bibb Mill machinery was powered by a rope drive system. The rows of machinery seem to go on endlessly, illustrating the immense length of the mill.

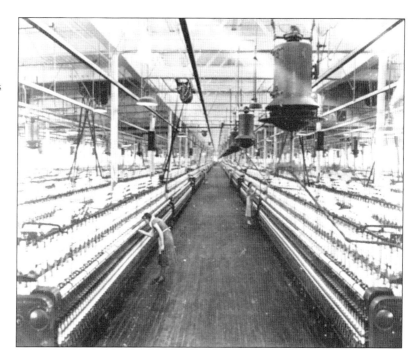

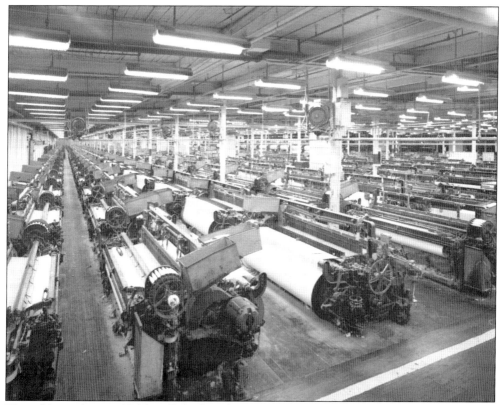

This additional view of Bibb Mill displays the equipment used for textile manufacturing.

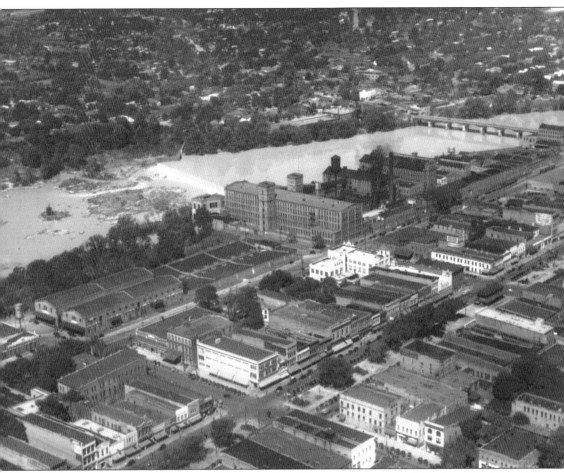

This aerial photograph shows just how vast the mill operations were in Columbus. The industrial riverfront development and the many businesses lining Broadway show Columbus's economic prosperity and contrast starkly when compared to the Alabama side of the river. The Georgia border encompasses the entirety of the river, meaning that Alabama businesses could not use it in the same way as Columbus, such as building dams to harness the power of the river.

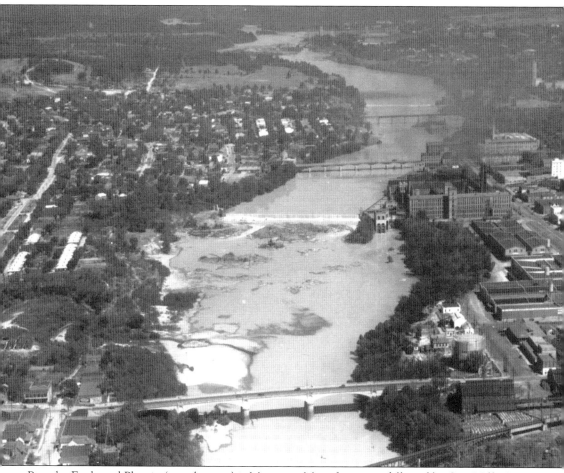

Past the Eagle and Phenix (near bottom) is Muscogee Manufacturing, followed by City Mills. In the distance, Bibb Mills can also be seen. The monolithic presence of the mills has contributed significantly to Columbus's history.

Originally from Massachusetts, John Rhodes Browne came to Columbus in 1851 to help Eagle Mill begin operating. However, he left manufacturing to become president of the Georgia Home Insurance Company. In addition to his banking and insurance interests, he was also involved in many other industries, including serving as president of the Columbus Manufacturing Company, a director of the Muscogee Mills, and owner of the Steam Cotton Mills. (Courtesy of Columbus Museum.)

Rhodes Brown (center) poses for a photograph with his family. He was the son of John Rhodes Browne, and upon his father's death, he took up his mantle, becoming a leading Columbus businessman. He also served as mayor of Columbus from 1908 to 1911.

George Gunby Jordan (1846–1930) was a leading industrialist in Columbus. He was involved in many businesses, including Eagle and Phenix, Columbus Power Company, Columbus Manufacturing, Bibb Mill, and many others. In addition to his leadership in the mills, he was centrally involved in railroad development, ensuring lines connected Columbus to the rest of the nation.

William Clark Bradley came to Columbus in 1885 at the age of 22. He was one of the most important individuals in the business and industrial history of Columbus. His hands touched nearly every business in the city. He was also a major philanthropist and an avid supporter of the arts. (Courtesy of W.C. Bradley Co. Archives.)

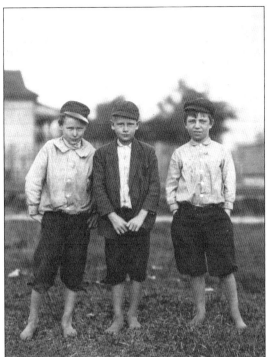

The textile mills employed numerous child laborers, taking advantage of their small hands to run textile machinery. Many families were forced to send their children to work due to low wages. Strict limitations were placed on child labor as part of Franklin Roosevelt's New Deal in 1934 under the Fair Labor Standards Act. Seen here are several children who worked at the Bibb Mill. (Courtesy of Library of Congress.)

A group of workers from the Meritas Mill is pictured here. Meritas began operation in 1909 and was primarily a yarn manufacturer. The Bibb Mill acquired Meritas Mill in 1937. (Courtesy of Library of Congress.)

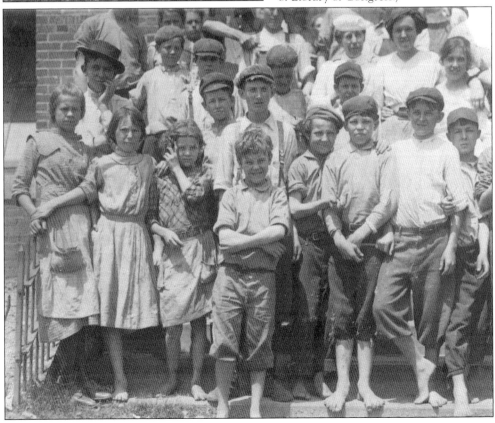

The Columbus mills also drew child laborers from nearby Girard (now Phenix City), where the youngest children came across the bridge as "dinner-toters," selling lunches to the mill workers. They would also linger around the mills learning to use the machinery in preparation for a future career there. (Courtesy of Library of Congress.)

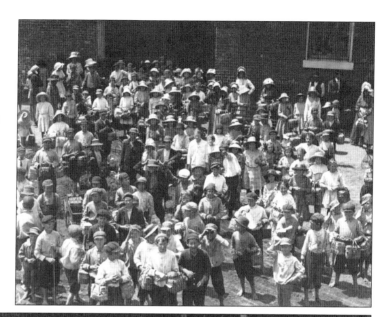

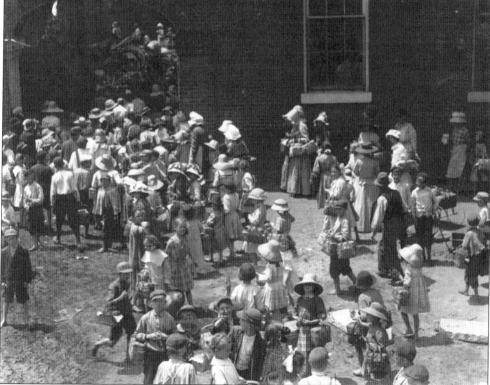

The original caption for this 1913 photograph reads, "Dinner-Toters waiting for the gate to open. This is carried on more in Columbus than in any other city I know, and by smaller children. Many of them are paid by the week for doing it, and carry, sometimes, ten or more a day. They go around in the mill, often help tend to machines, which often run at noon, and so learn the work. A teacher told me the mothers expect the children to learn this way, long before they are of proper age." (Courtesy of Library of Congress.)

Judge George C. Duy was one of the founding members of the Free Kindergarten Association of Columbus. According to the petition of incorporation, its mission was "to establish and maintain free kindergarten schools in the city of Columbus and vicinity for the education and moral training of the children of the poor, and for the material maintenance of these for whom their parents are unable to make adequate provision."

Lucy Duy, wife of George Duy, was instrumental in establishing the Free Kindergarten Association and its subsequent operation, serving as its vice president. The operation was founded in large part due to the many poor children in the mill communities.

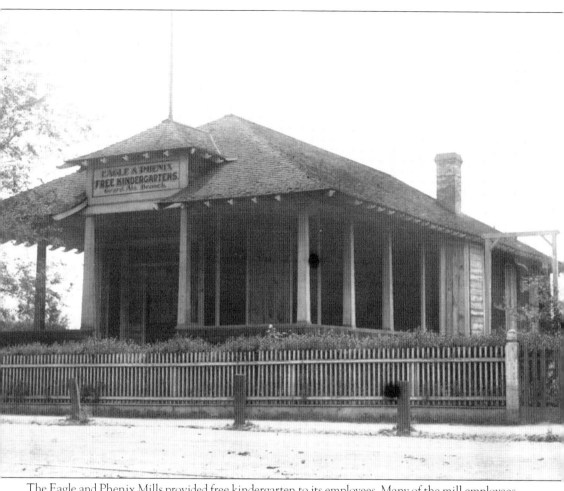

The Eagle and Phenix Mills provided free kindergarten to its employees. Many of the mill employees lived in Girard, Alabama, forming a mill community, which is where this educational building was located. (Courtesy of Library of Congress.)

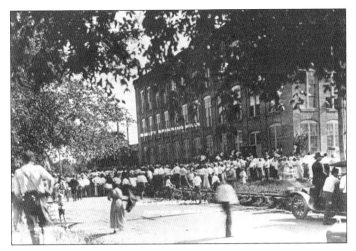

With large manufacturing operations often comes a large labor union presence. The unions did have a presence in Columbus, primarily in the textile industry. The national textile strikes of 1919 and 1934 sent shockwaves through the city, but both were unsuccessful for the unions. This photograph shows a textile strike in front of the Swift Mill.

Textile unions were not alone. The International Alliance of Theatrical Stage Employees and Moving Picture Machine Operators (IATSE) had a local chapter in Columbus. In this photograph, a group of local members protests outside Martin Theaters around the 1920s. Martin Theaters was the predecessor to Carmike Cinemas, which has become one of the largest movie theater companies in the nation.

Occasionally, the police were called to intervene in strikes. In this photograph, the Columbus Police Department shows off its new uniforms in front of the courthouse in 1903. The man at front center is Mayor Lucius H. Chappell, who restructured the police department, emphasizing merit and professionalism for the first time.

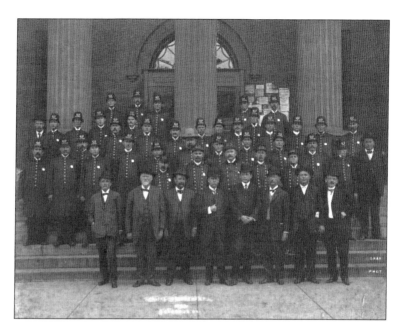

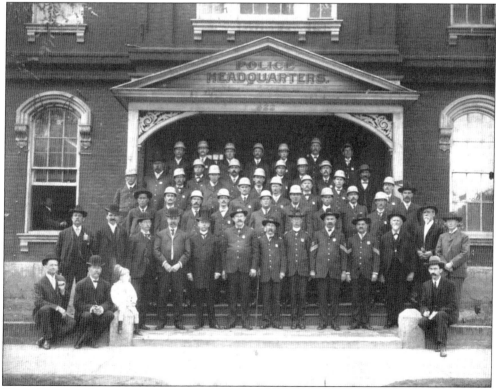

The police gained a new headquarters in 1906. In this photograph, the department proudly poses in front of the old headquarters known as the Columbus Stockade.

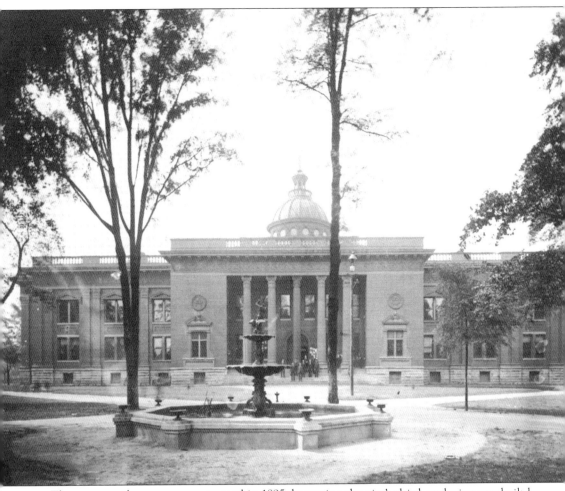

The new courthouse was constructed in 1895, becoming the city's third, replacing one built by John Godwin and Horace King in 1840. The building featured large columns and an impressive dome, and the grounds around the courthouse were well manicured, creating a park-like setting for citizens to visit. One resident remarked of the courthouse, "If this were in some foreign country we would think it grand. We often fail to appreciate the everyday blessings."

At the center of this photograph is Mayor Lucius H. Chappell. He served as mayor from 1898–1907, and after a voluntary retirement, returned as mayor in 1911–1913. He led a revolution in city politics, outing a corrupt political ring and leading Columbus into a new era, promising "to every citizen of Columbus, white and black, rich and poor . . . an honest, clean, impartial and progressive city government."

This is a photograph of Jennie Hart, Lucius H. Chappell, Loretto Chappell, Lucy Kent, and Bentley Chappell in front of their home at 1430 Third Avenue. Lucius's example of civic engagement and public service continued with his children. For example, Bentley served as city attorney, and Loretto led the public library for decades.

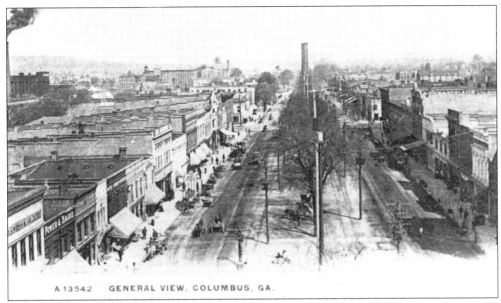

A vibrant downtown Columbus scene, with businesses lining Broadway, is depicted in this c. 1905 image. Life in Columbus was lively at the turn of the 20th century. Mayor Chappell was responsible for the beautification of downtown, including lining the streets with trees, as seen here.

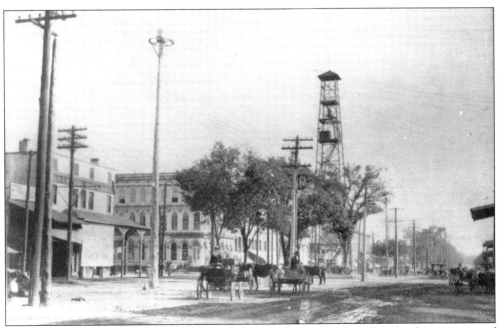

The bell tower alerted city residents and volunteer firefighters to fires. Despite the proximity of the Chattahoochee, the city had problems maintaining an adequate water supply. This changed in 1914 thanks to the work of the Municipal City Water Works supported by Mayor Chappell.

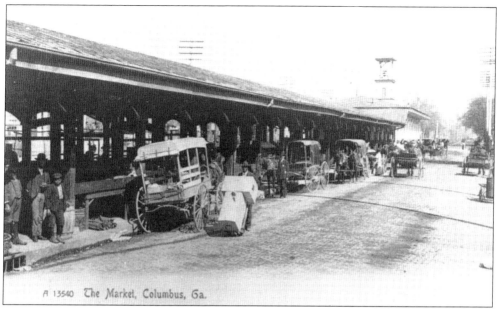

The city market was located on First Avenue between Tenth and Eleventh Streets. The many stalls offered residents meats, vegetables, and other essential goods. This c. 1906 view also shows the bell tower, which warned residents of fires.

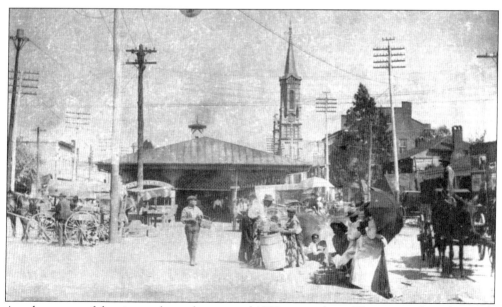

Another scene of the city market, taken around 1900, is seen here. This view is from the south end and looks north. The market was a mainstay of Columbus for decades but was removed in 1924.

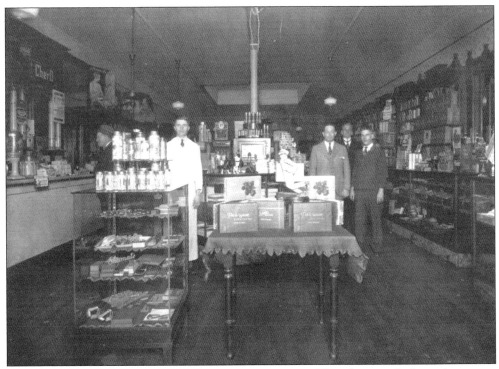

This photograph shows the interior of Smith's Drug Store at 1002 Broadway. Shops like this dominated Broadway in the early 1900s. The owner, H.C. Smith, operated three drug stores, with other locations at 701 Third Avenue and 1401 First Avenue. He was also politically active in Columbus, serving a term as mayor in 1932.

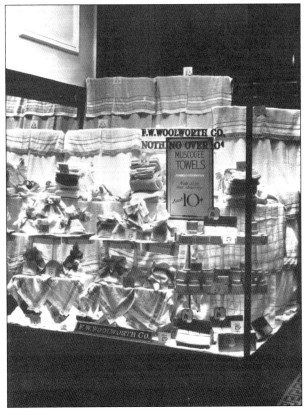

F.W. Woolworth Store was also located on Broadway, at 1112. The store sold items that were all 10¢ or less. A selection of locally made Muscogee Towels is seen in this window display.

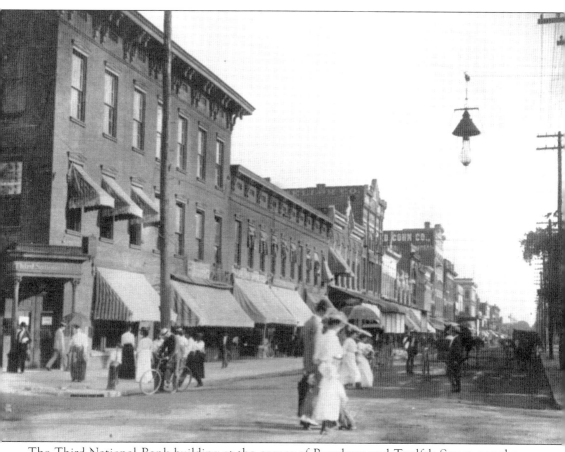

The Third National Bank building at the corner of Broadway and Twelfth Street was the predecessor to the Columbus Bank and Trust Company and the Synovus Corporation. The Third National Bank and Columbus Savings Bank merged in 1930, forming the Columbus Bank and Trust Company. Synovus, originally called CB&T Bancshares, was created in 1972 to act as a bank holding company.

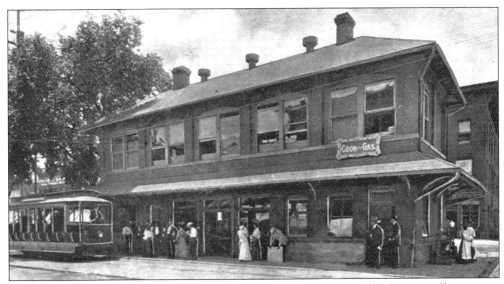

In addition to steamboats and railroads, citizens could also get around by electric trolley service. The transfer terminal is seen here in 1907. Services such as this and the later spread of automobiles encouraged the growth of suburbs and led to citizens moving to areas on the outskirts of the city such as East Highlands, Waverly Terrace, Wynnton, and Overlook.

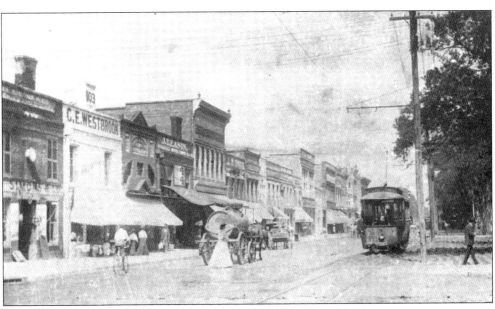

This photograph captures a unique perspective. Columbus is transitioning into a new era, as new electric trolley cars travel alongside horse and buggies.

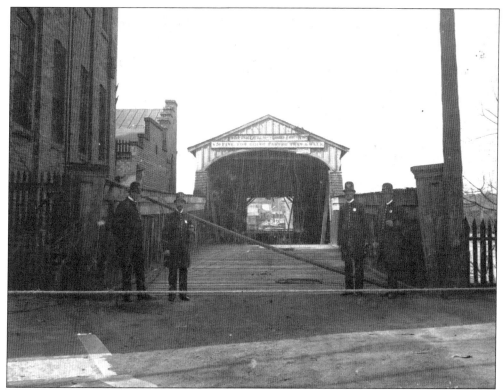

Police officers guard the old Fourteenth Street covered bridge, built by Horace King, after it was destroyed in the 1902 flood. The sign above the bridge reads, "$20 fine for going faster than a walk." There was also a $5 fine for riding a bicycle across the bridge.

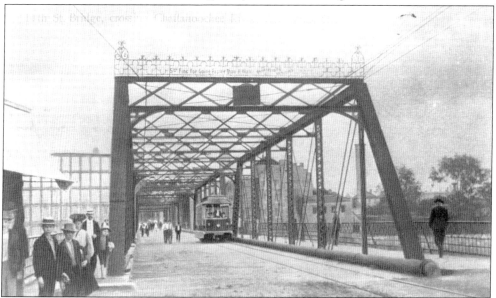

The steel girder bridge that replaced the old Fourteenth Street covered bridge is seen here from the Alabama side of the river. It features an electric trolley line connecting Columbus to Girard. By this time, around 1912, the fine for going faster than a walk had been reduced to only $5.

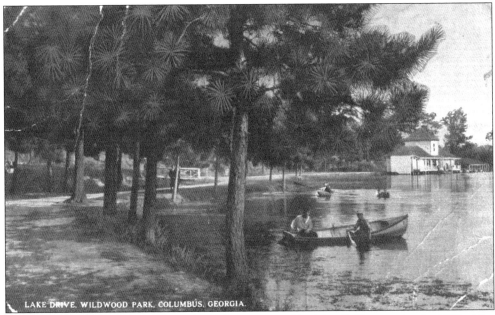

The Wildwood/Lakebottom/Weracoba Park was created by John F. Flournoy in the 1880s. The area was once home to a sprawling lake park with boating, fishing, and swimming. There was also an ice cream shop, auditorium, skating rink, and even a zoo. Silent movie viewings, band performances, and the annual Easter egg hunt were all much-loved activities there.

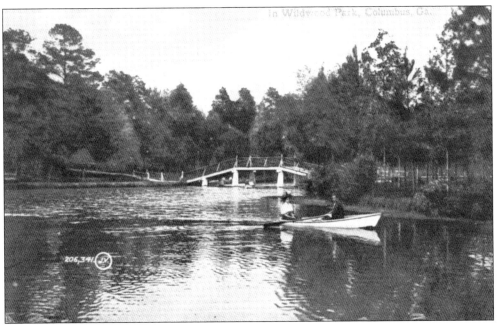

The lake was drained in the 1920s due to several reasons. Most significant was the flu epidemic of 1919, but also because avenues of entertainment were changing as radios, motion pictures, and automobiles led to faster-paced lives where picnics and park outings became outdated.

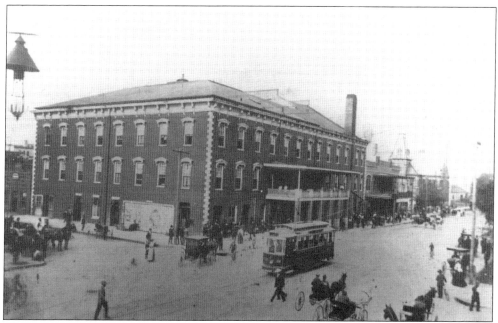

The beautiful Springer Opera House, the home of Columbus theater, is seen here around 1895. Francis Joseph Springer originally built it in 1871. It hosted local benefits and amateur productions, as well as national road shows and other touring acts. Edwin Booth, brother of John Wilkes Booth, performed here, as well as other well-known performers such as Oscar Wilde. Political leaders such as Eugene Debs and William Jennings Bryan also gave speeches here.

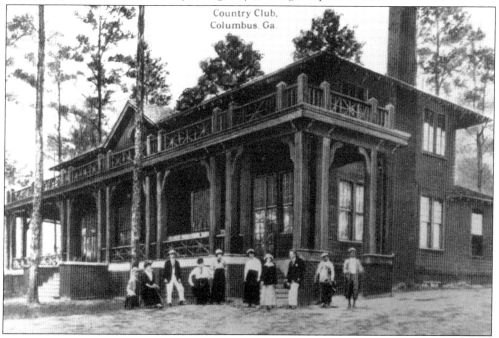

The Columbus Country Club on Cherokee Avenue was founded in 1909. This building burned in 1919. The clubhouse that replaced it stood until the 1940s, when it was replaced by the present one.

Founded the same year as the city, 1828, the Columbian Lodge of the Free and Accepted Masons has had a long presence in the city. Charter members of the lodge included C.I. Atkins, Edwin E. Bissell, Luther Blake, William Carter, F.S. Cook, Thomas Gordon, Isaac Holland, William Lucas, Thomas Miller, Pleasant Robinson, Beverley Rue, and Ira Scott. In this c. 1900 photograph, Mayor L.H. Chappell, who was also a member, is standing at center.

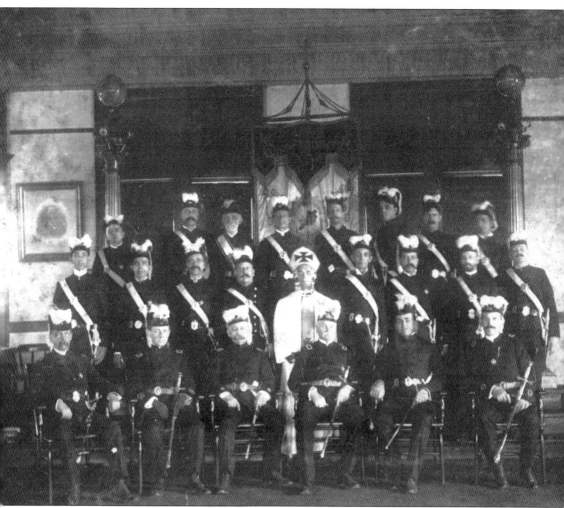

The St. Aldermar Commandery of the Knights Templar was founded in 1857 as the third commandery in Georgia. Original members include James Albertson, Robert Allsworth, James Bivins, Francis Brooks, Michael Clarke, James Clower, J.R. Daggers, Philip Gittenger, Simon Holt, Charles Levye, A.B. Ragan, and Thomas Tuggle.

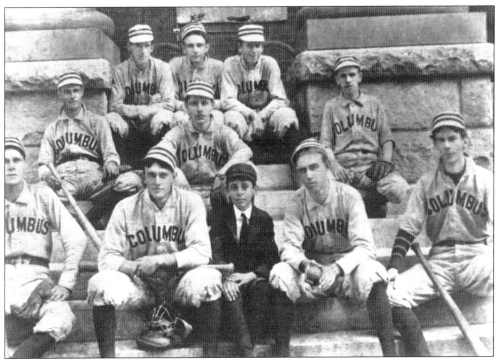

Baseball was a popular pastime in Columbus, with roots in the city since the late 1860s. Since that time, Columbus has had many amateur and professional teams. In 1888, John F. Flournoy purchased a franchise in the Southern League. This photograph shows Columbus's team around 1896.

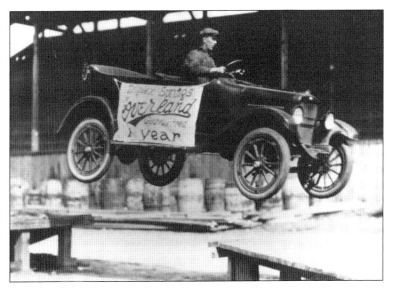

Locals had fun at an event sponsored by Overland Tire Company at the local fairgrounds in 1921. Here, Charles Jenkins demonstrates the durability of Triplex Springs.

Columbus obtained its first public library in 1907. It was a Carnegie Library, meaning it was built with money donated by Andrew Carnegie. It operated on Mott's green on upper Broadway until the Bradley Memorial Library opened in Wynnton in 1950.

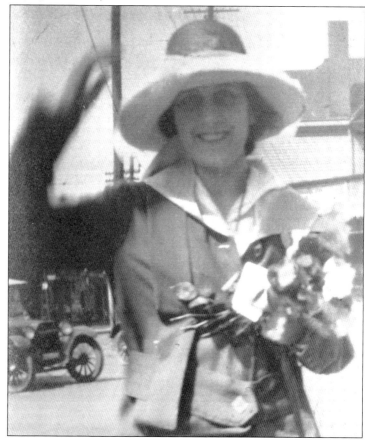

Loretto Chappell spent nearly her entire life with the public library. She first volunteered at the Columbus Carnegie Library in 1908. She later went to library school in Cleveland, Ohio, which is where this photograph was taken. She is waving goodbye to her friends as she prepares to return home.

John McIlhenny came to Columbus in 1857 from Philadelphia to start the Gas Light Company. He was instrumental in establishing the local school system, which was incorporated in 1867. He was also an active business investor and political leader.

Wynnton School originally opened as a one-room schoolhouse in 1837 operating as a private academy for children of the elite in Wynnton. The building pictured here was built in 1923.

With the first classes held in 1890, Columbus High School became the first public high school for white students in Columbus. Classes were held at temporary locations until the original Columbus High School building opened on Third Avenue and Eleventh Street in 1898.

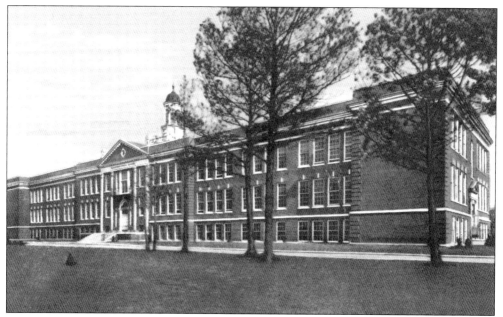

Columbus High moved to a new building at 1700 Cherokee Avenue in 1926, where it overlooks Wildwood Park. The costs for construction and purchasing the land were paid for by bond sales that the city overwhelmingly approved in 1924.

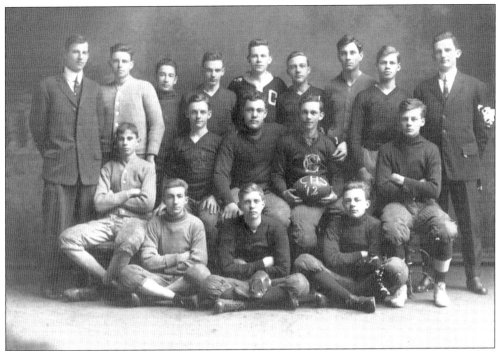

The Columbus High School football team, pictured here in 1912, was 3-1 that year, losing only one game to Auburn High School. Players included Campbell Johnson, Robert Carter, Wilfred Gross, John Lewis, Ralph Walton, Terrell Hill, Harry Rodgers, Alfred Dolan, Owen McNulty, Frank Lyon, Herbert Groover, William Golden, Roy Scott, Walter Wyatt, Allen Clapp, Max Levinson, Frank Billings, and Harry Reich. The coaches were Robert Joerg and W.P. McElroy.

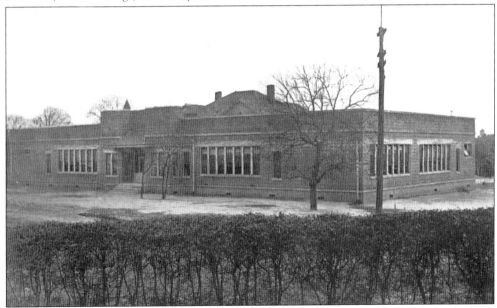

Claflin School was the first public school for African Americans in Columbus. It was built by the Freedmen's Bureau and opened in 1868. This photograph shows an expansion built in 1921, adding on to the original wooden building. (Courtesy of Columbus Museum.)

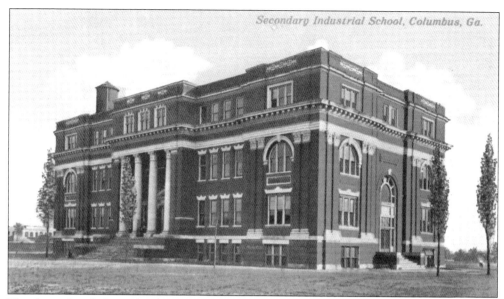

The Secondary Industrial School was built in 1906 on land donated by G. Gunby Jordan, and was the first industrial or vocational high school in the country. It met the need to provide skilled workers for Columbus's industrial economy. In 1937, it became a junior high school, and the new Jordan Vocational School replaced it as a high school.

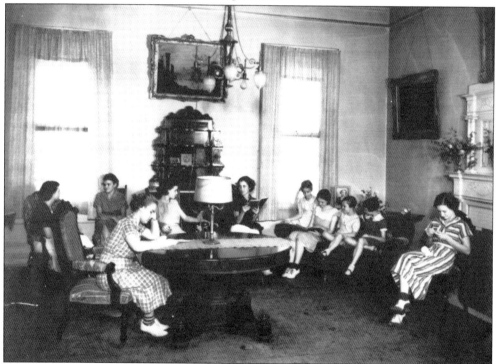

The Anne Elizabeth Shepherd Orphans' Home dates to the 1840s, when a women's group from St. Luke Methodist Church established it. It gained the "Shepherd" name in 1924 when Col. W.S. Shepherd bequeathed his home to the organization. It was primarily an orphans' home for girls, as this photograph, probably from the 1920s, illustrates.

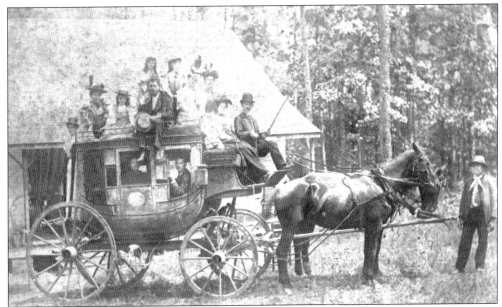

This photograph shows one of the stagecoaches that carried travelers between Columbus and Warm Springs. Columbus families frequently vacationed in nearby Warm Springs. They often announced their vacations in the newspaper, indicating when they would be "rusticating" or "summering" away from home, so that their friends would not be looking for them.

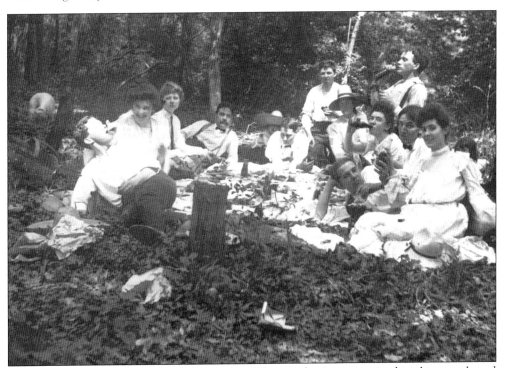

An unidentified family takes time for a picnic. The simple times seen in this photograph and the one above were becoming rarer, as Columbus was transitioning into the fast-paced life of the Roaring Twenties.

Four
A New Columbus

While the importance of the mills to Columbus cannot be overstated, their dominance would not last forever. The Great Depression marked the beginning of their decline, and by the 1980s, most were out of business. Columbus needed to reinvent itself. There were many factors leading to change in the city and the creation of a new Columbus. Indeed, the 20th century was a turbulent, change-filled time for the city. Women's suffrage, Prohibition, two world wars, and civil rights were all challenges the city had to face. One major player in changing Columbus was Fort Benning; its impact on the city has been massive. However, perhaps the most important event in creating a new Columbus was the establishment of Columbus College in 1958. This allowed for a diverse and educated citizenry, which in turn allowed the city to evolve from a sleepy mill town to a modern 21st century city that major Fortune 500 businesses such as Aflac, Total Systems, and Synovus call home. This brought Columbus into a new era, but at the same time, Columbus has embraced its past. In the 1960s, efforts at urban renewal and revitalizing the downtown district returned Columbus to its roots. Focus on historic preservation and adaptive reuse have been hallmarks of Columbus's progress—a place where the old meets the new.

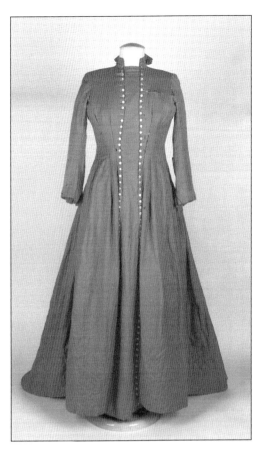

Helen Augusta Howard was a strong supporter of women's rights and equality in Columbus. This dress, dated to 1891, is believed to have been owned by her during her most active time, as 1890 was when she established a branch of the National American Woman Suffrage Association in Columbus. It is also believed that she wore this specific dress to the National American Suffrage Association Convention in Atlanta in 1895. Women finally gained the right to vote by the 19th Amendment in 1920. (Courtesy of Columbus Museum.)

Prohibition was a time of stark division in Columbus. People were aligned on opposite sides, as medical doctor William Gann demonstrates in this letter to the newspaper. Concerns over religion, political corruption, and medical use were all issues of contention; as Gann states, "I defy any physician to prove that whiskey does not have a good effect, with poor weak, emaciated consumptives, it mitigates the cough, cheers up the feelings and softens the path to the grave."

Prohibition Discussed by Columbus Doctor

Prohibition advocates seem to be in favor of putting every one on the rock pile, who may be caught with a bottle of whiskey, except themselves and their son John. This remedy being based on the assumption that prohibition is right and must be enforced: I beg to say that prohibition is wrong and can't be enforced, just follow me into the home of a husband or a father, who has a wife or a daughter slowly dying with consumption, see the poor weak, loved one growing weaker and more feeble with no hope of relief, except in the grave, the husband or father devoting his life to making enough to buy the bare necessities, let him wake up in the dead hours of the night and hear the cough of his loved one, in despair he begs a merciful, father to comfort them in their sadness; he remembers the bottle of whiskey is nearly gone and must be filled before another night. Catch this man and put him to work on the roads? Yes, say the prohibitionists, he has violated the law and must be punished, no, says justice, he is only caring for his loved ones.

I defy any physician to prove that whiskey does not have a good effect, with poor weak, emaciated consumptives, it mitigates the cough, cheers up the feelings and softens the path to the grave.

I don't care who the man is, how well educated, or what position in life he holds; he can't refute this assertion and I defy any one to disprove it; if the prohibition officer is a prohibitionist, he will try to catch this husband or father, claiming the law is right and must be enforced. If on the other hand, the enforcement officer is not a prohibitionist, he will say, the law's wrong, I need the money to feed my family and will take a tip from both sides; make money while the sun shines and without any remorse of conscience, put aside something for a rainy day. With due respect to the prohibitionists, be they women, preacher, politician or a common ignorant fellow, led by the nose into a ditch, I make this assertion; no one can be a prohibitionist and a christian, my authority for this is the teachings of the Bible in the Old Testament, I call your attention to Noah and Lott and ask you to read and form your own opinion.

In the New Testament, Christ says, Mathew, chapter 26 verse 29, but I say unto you, I will not drink henceforth of the fruit of the vine, until the day I drink it new with you in my father's kingdom. Mark, chapter 14 verse 25: Verily I say unto you, I will drink no more of the fruit of the vine, until that day I drink it in the kingdom of God. Luke; chap. 22 verse 18: For I say unto you, I will not drink of the fruit of the vine, until the kingdom of God shall come.

Now, I defy the whole world to disprove the above quotations, or take them and manufacture a christian out of prohibitionist. No one doubts Christ's own words; the conditions of our country, are deplorable and nothing can save us from ruin, except christianity; not the prohibition hypocrit.

I am doing my best to live a useful and a christian life and I hope when it is over and I am called to the great beyond, my Saviour will meet me at the portals of heaven with a glass full of the promised fruit of the vine. I am sure it will be good and I will be happy.

DR. W. F. GANN,
2900 Second Ave.
Columbus, Ga., Nov. 23, 1925.

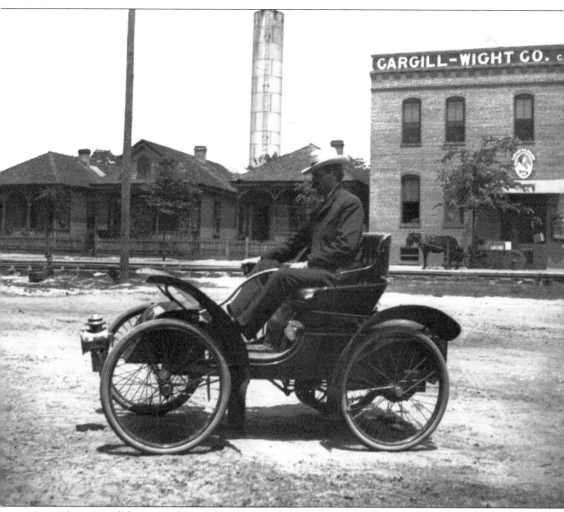

An early automobile is seen here around 1900. At this time, very few people around the world could boast of owning one. Leon Camp brought the first car to Columbus in 1901. He was charged with reckless driving after he lost control in a sandy spot at the intersection of Twelfth Street and Broadway. In his attempt to get traction, he gave the car full throttle, which resulted in it leaping out from the road and onto the sidewalk, where it pinned a screaming pedestrian against a building and broke a shop window. The charges did not stick, however, as there were no laws against reckless driving. In the background of this photograph is the Cargill-Wight Company, built in 1902, which was a candy manufacturer and syrup refinery.

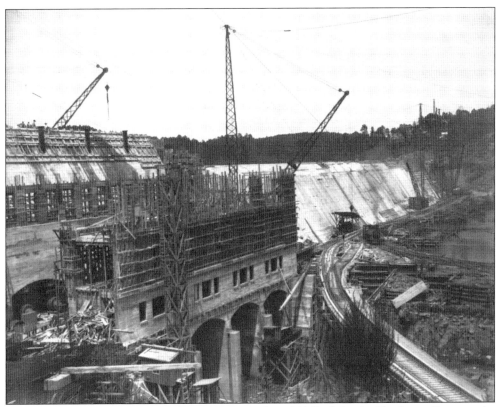

Construction began on Goat Rock Dam in November 1910. Built by the Hardaway Company by an estimated 1,000 workers, the dam is 70 feet high and 1,320 feet long. The dam was named for the area's rocky terrain and nearby goat population. Workers saw the goats climbing the rocks, and the name stuck.

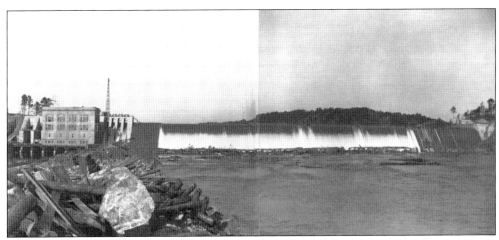

Goat Rock Dam represents a major milestone for Columbus in the development of hydroelectric power. Previously, milldams generated small amounts of power, limited mainly to mill operation. However, with Goat Rock, the power of the river was harnessed on a broader scale, providing the ability to send electricity to large areas.

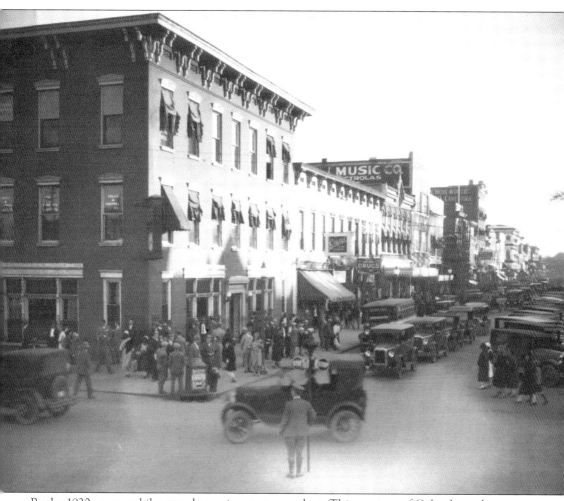

By the 1920s, automobiles were becoming more prevalent. This was true of Columbus, where an early traffic jam has caused some congestion at the corner of Twelfth Street and Broadway. The Roaring Twenties were also a time of mass consumerism. People were out and about spending money by shopping, experiencing new entertainment venues, and eating out at new restaurants.

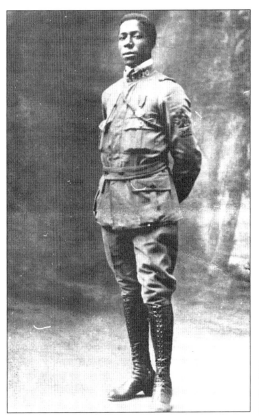

A native of Columbus born in 1895, Eugene Bullard became the first African American fighter pilot. He left Columbus to escape racial discrimination and traveled to Europe, ending up in France during World War I. He volunteered as part of the French Foreign Legion, participating in over 20 combat missions. He was highly decorated for his service and received numerous awards, as well as becoming a knight of the Legion of Honor, one of France's highest awards. After the war, he became a prominent night club owner and manager in Paris. During the Nazi occupation of France in World War II, Bullard returned to the United States, living in New York City, where he died in 1961.

Americans, like Eugene Bullard, participated in World War I much earlier than the official US declaration of war, but when that time did come in April 1917, the United States committed millions of soldiers to the wartime effort. George W. McKenney, pictured here, was one Columbus resident who became a doughboy to serve his country. He served for roughly one year, being inducted on September 5, 1918, and discharged due to demobilization on September 12, 1919.

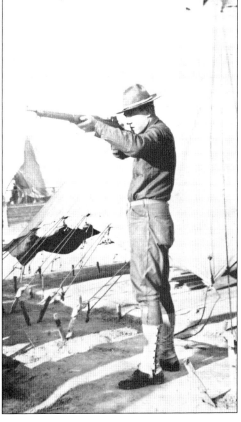

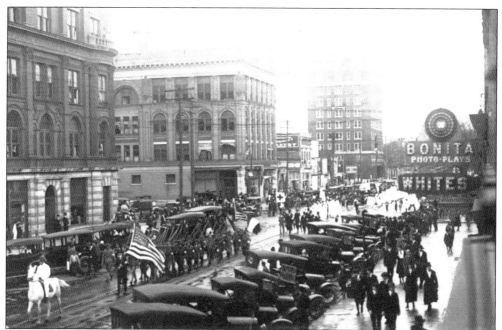

A Junior Red Cross parade is pictured on Twelfth Street during World War I on February 14, 1918. L.H. Chappell on a white horse leads 4,000 children followed by Boy Scouts, the mayor, and the superintendent of public schools.

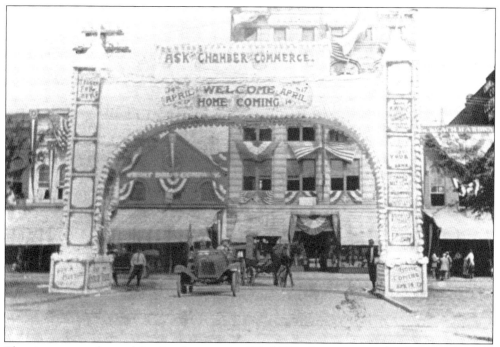

The city prepares for a celebration for returning World War I veterans to take place April 14–17, 1919. Broadway buildings are decorated including an Arch of Triumph with the message "Welcome Home Coming."

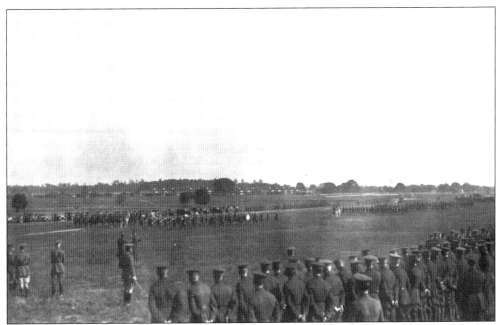

Camp Benning was established in the fall of 1918 as the new site for the Infantry School of Arms, which was relocating from Fort Sill, Oklahoma. In 1922, the camp attained permanent status, becoming known as Fort Benning. The soldiers marching here on the parade fields are being reviewed by their superior officers.

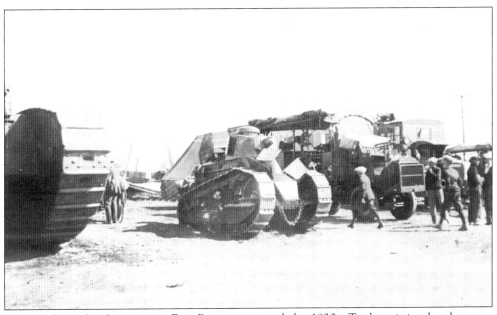

Early tanks make their way to Fort Benning around the 1920s. Tank training has been an important part of Fort Benning since its beginning. At this time, tanks were used as infantry support. There were experiments using tanks as distinct fighting forces in the two world wars, but armored divisions did not gain permanent status until 1950.

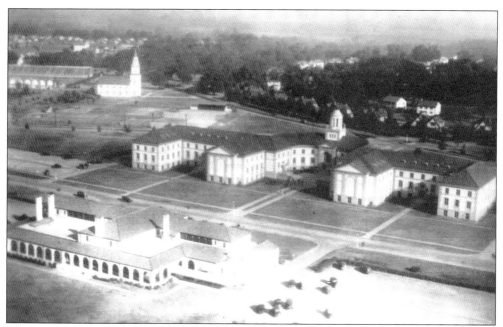

The Infantry School, Officer's Club, and Post Chapel are three of the most recognizable buildings on Fort Benning. Doughboy Stadium can also be seen directly behind the chapel. (Courtesy of Kenneth H. Thomas Jr.)

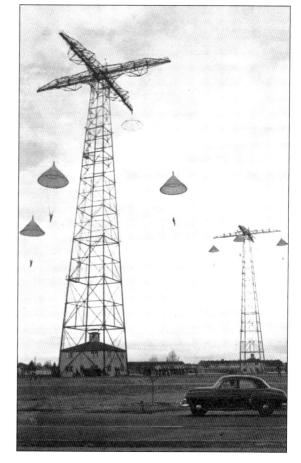

The jump towers are icons at Fort Benning. They were completed in 1941–1942 and represent an integral part of training at the airborne school; this was an important first step before jumping from an aircraft. This 1964 photograph shows jumpers from the 250-foot tower. (Courtesy of Kenneth H. Thomas Jr.)

Fort Benning continued to expand, and by the time of World War II, had a substantial presence in the city. Soldiers often spent their free time in downtown Columbus, where they stimulated the local business economy. (Courtesy of Library of Congress.)

Soldiers on leave are lined up at the bus terminal for a quick trip before returning to duty. Some may have been looking to reunite with family, while others were perhaps looking for a good time in neighboring Phenix City, Alabama. (Courtesy of Library of Congress.)

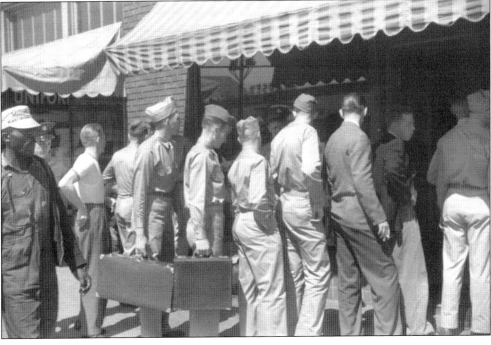

During the 1940s and 1950s, Phenix City was known as "Sin City" due to the prevalence of organized crime, gambling, and prostitution. Soldiers stationed at Fort Benning were regular visitors here and were often taken advantage of by the local crime scene. According to some accounts, Gen. George S. Patton, while stationed at Fort Benning, threatened to roll his tanks into Phenix City and flatten the gambling halls that were preying on his troops. Albert Patterson, a candidate for Alabama attorney general, was murdered in Phenix City on June 18, 1954, because of his platform to reform the city. This led to martial law and the deployment of 75 Alabama National Guardsmen, who cleaned up the city by force.

Many natives of Columbus fought during World War II and ended up making the ultimate sacrifice. One example is Lt. Col. Amzi Rudolph Quillian. He graduated from West Point in 1937 and was assigned to the 66th Infantry at Fort Benning. He survived the D-Day assault at Normandy, only to be killed in battle shortly afterwards at Saint-Lô, France, on July 28, 1944. He had a daughter, Sally, who he never met. While in Europe, he wrote a letter to his daughter, "The reason for this letter is that because of the business I'm engaged in it is possible that I may never get to see you. . . . If I do get to see you this letter is pointless and should be destroyed but if I shouldn't I want you [to] know how I feel about the reason for it. We are living in a time now when soldiers must be willing to die for their country or else we won't have a country. I won't go into detail because you will read it all in your history books. Of course, I am willing to die if necessary but before I go I expect to make many Germans die for their country."

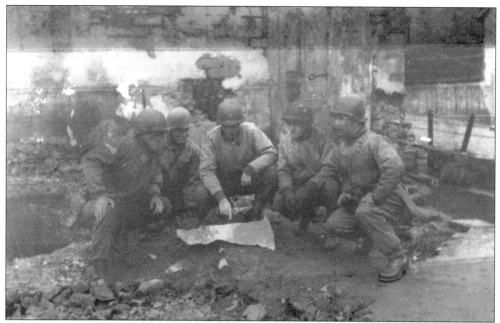

Aaron Cohn, born in Columbus on March 3, 1916, served in World War II, achieving the rank of lieutenant colonel. During the war, he was a combat operations officer for the 3rd US Cavalry, which liberated the concentration camp at Ebensee, Austria, in 1945. After the war, Cohn practiced law, and in 1965 was appointed judge of juvenile court, a position he held for over 40 years.

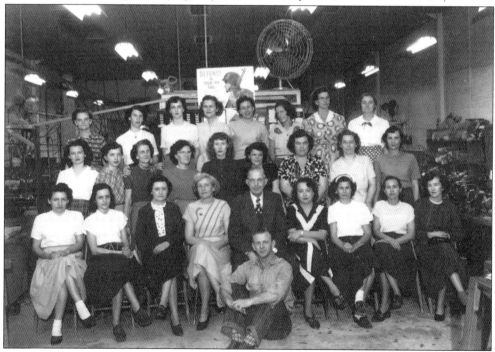

Residents of Columbus at home also contributed. The Schwob Manufacturing employees pictured here did their part to support the war effort during World War II. Businesses across the nation had to retool their manufacturing lines to meet the wartime needs of the government.

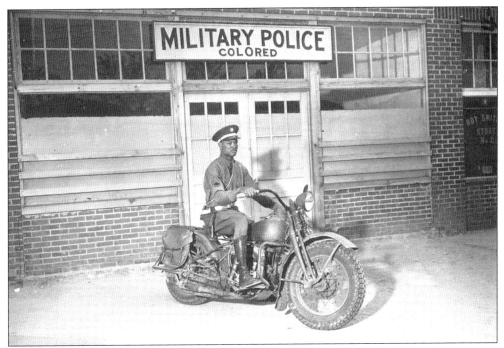

Pres. Harry S. Truman ordered the military to integrate in 1948. The Army's policy of integration helped Columbus confront this difficult challenge. Fort Benning's presence and influence in the city had a tremendous effect and helped Columbus make a smooth transition through the civil rights period. (Courtesy of National Archives.)

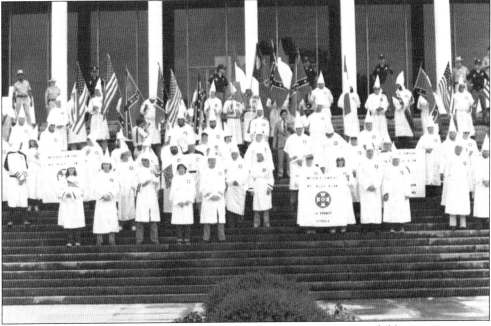

There were some who resisted an integrated society. The Ku Klux Klan did have a presence in Columbus and often rallied and marched openly in the city streets. Its boldest period was in the 1950s and 1960s, when it terrorized locals who supported civil rights.

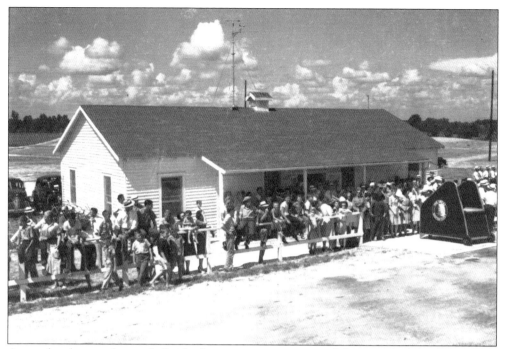

A crowd gathers at the newly finished airport in anticipation of the arrival of the first aircraft. The airport received its first flight on August 1, 1944, when Eastern Airlines airmail came to Columbus. The administration building in this photograph was constructed for less than $1,000. This was to skirt wartime regulations, as the War Production Board would not approve the planned $65,000 construction. The originally planned building was constructed later, after the war.

The Columbus Museum gained a new home in 1953 with the gift of the W.C. Bradley residence. The home is shown here when the Bradleys still lived there, before it was converted to the museum. The creation of the museum was a major event in the cultural development of Columbus. (Courtesy of W.C. Bradley Co. Archives.)

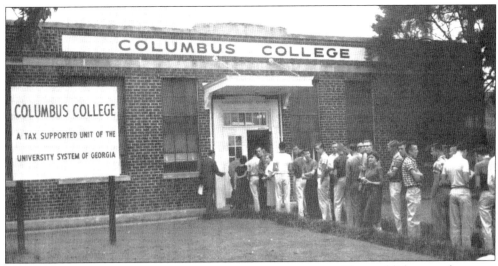

The establishment of Columbus College in 1958, now Columbus State University, helped Columbus transition from a sleepy mill town to a diversified business center and fueled substantial economic growth. In this photograph, students are lined up to register for classes at the original location of Columbus College, the Shannon Hosiery Mill.

This image shows the construction of Columbus State University's centerpiece, its clock tower. It was constructed from bricks saved from the Shannon Hosiery Mill. The university moved out of the hosiery mill to a new campus, the site of a former dairy farm, in 1963.

John Townsend was the first African American student to attend Columbus College. He registered and attended classes in the fall of 1963 without violence and graduated in June 1965 with an associate's degree. He is pictured here as a member of the Student Government Association.

In this 1991 photograph, students achieve the ultimate college goal: graduation. The 59th commencement was held on the lawn near the clock tower with the university awarding 75 associate degrees, 288 bachelor's degrees, and 50 graduate degrees.

Carson McCullers, born and raised in Columbus, was a world-renowned author. In many of her works, she drew inspiration from her childhood in Columbus, with one of her most famous works being *The Heart is a Lonely Hunter*. McCullers lived in Columbus until 1934, when she moved to New York City at the age of 17. While in Columbus, she attended and graduated from Columbus High School. She suffered from several physical ailments and died at the age of 50 in 1967.

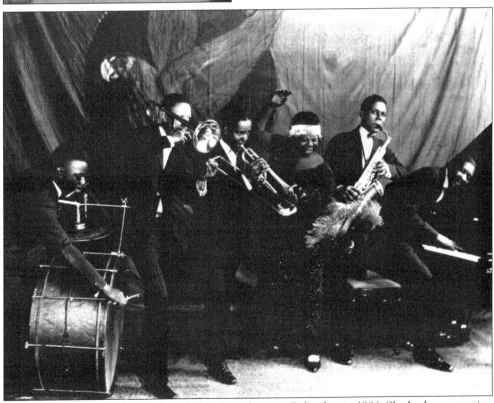

Ma Rainey, known as "the Mother of Blues," was born in Columbus in 1886. She had an extensive recording and touring career in her own right and worked with other leading musicians of the time, such as Louis Armstrong and Thomas Dorsey. She retired to Columbus in 1935, dying only a few years later in 1939 at the age of 53. (Courtesy of Columbus Museum.)

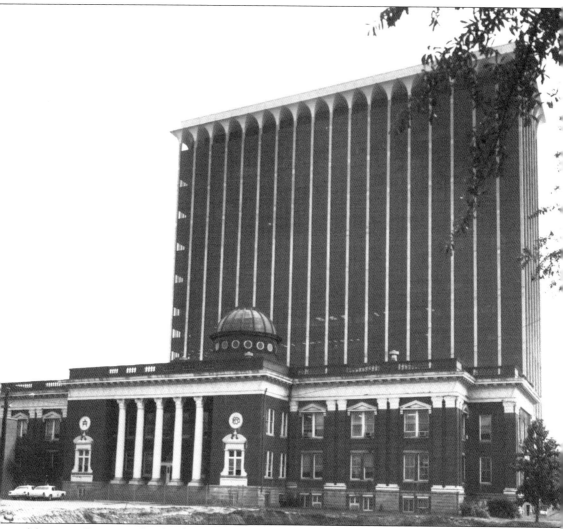

Muscogee County and Columbus city governments consolidated in 1971. A newly constructed Government Center provided a centralized location for government offices. It also replaced the old courthouse, which was demolished shortly after this photograph was taken. (Courtesy of Herb Cawthorne.)

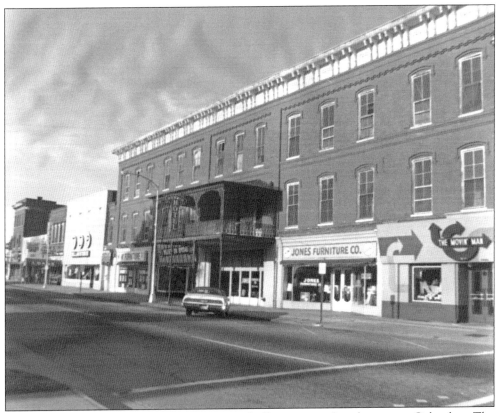

Beginning in the 1960s, there was a concerted effort to revitalize downtown Columbus. The development and renovation of Rankin Square was one of the first large-scale projects to revitalize the area. Harry Kamensky spearheaded the efforts, working diligently to preserve the historical buildings. The Rankin Hotel, seen here, was a staple of downtown Columbus for nearly a century. It was built in 1880 and provided a relaxing destination for weary travelers.

Built in 1854, Muscogee No. 3, being worked on in this photograph, is the oldest existing firehouse in Columbus. It ceased operating as a firehouse in the 1860s after it was merged with other fire companies.

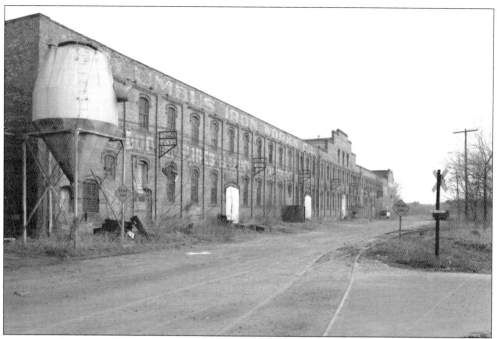

The Columbus Iron Works was renovated and transformed into a convention center in the late 1970s. This photograph shows the riverside exterior in the early 1970s before restoration. (Courtesy of Library of Congress.)

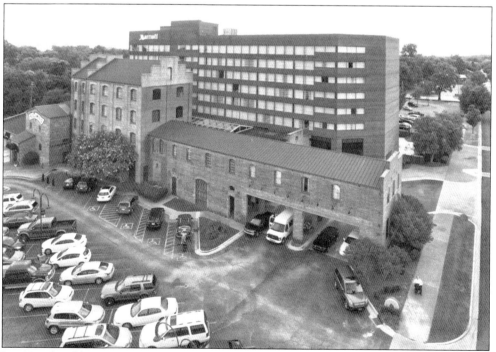

In 1982, the old Empire Mills building was converted into a hotel. It features all the old charm and industrial character of the old mill building, while also offering guests all the modern-day comforts and conveniences they expect. (Courtesy of Jim Gates and Bill Edwards.)

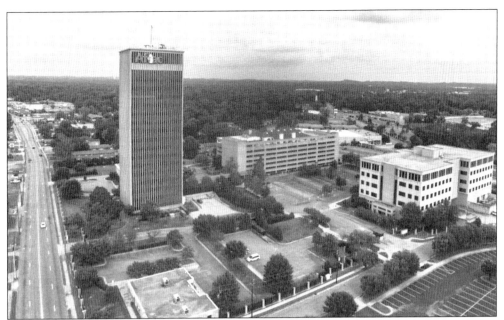

American Family Life Assurance Company, better known simply as AFLAC, was founded in Columbus by brothers John, Paul, and Bill Amos in 1955. It has become one of the leading insurance providers in the world. (Courtesy of Jim Gates and Bill Edwards.)

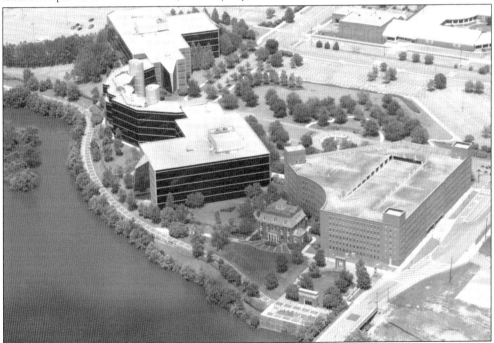

Total Systems, a global credit card–processing company, built its sprawling campus on the downtown riverfront, helping to revitalize the area. It also worked to preserve history and the historical feel of the old mill buildings, such as in the facade of its parking garage, done in the style of the Muscogee Mill. It also had plans to restore the Mott House until it burned in 2014. (Courtesy of Jim Cawthorne.)

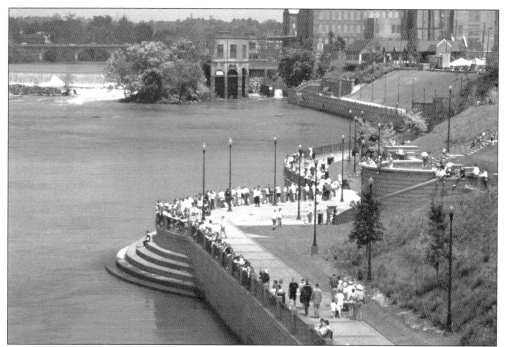

In 1989, construction began on the RiverWalk, with the first phase finishing in 1992. Subsequent phases extended the RiverWalk with it now reaching over 15 miles. This photograph was taken in the mid-1990s, with people lining the still-new walk enjoying its views of the Chattahoochee. (Courtesy of Jim Cawthorne.)

Opening in 2002, the River Center heralded a new era of performing arts and cultural events in downtown Columbus. Housed alongside the River Center is CSU's Schwob School of Music. (Courtesy of Lisa Roy.)

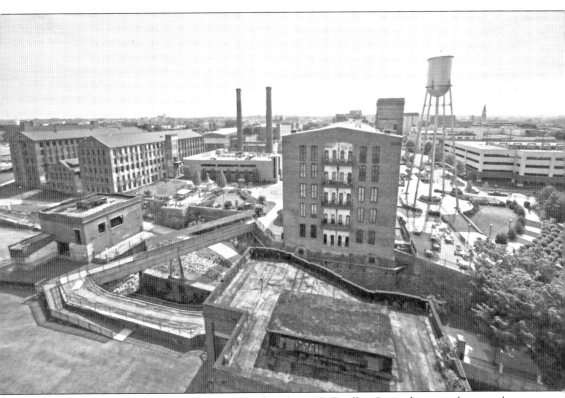

The Eagle and Phenix Mills were renovated by the W.C. Bradley Co. and are now home to luxury loft apartments and condominiums. The Epic Restaurant, an upscale dining establishment, is also located here. (Courtesy of Jim Gates and Bill Edwards.)

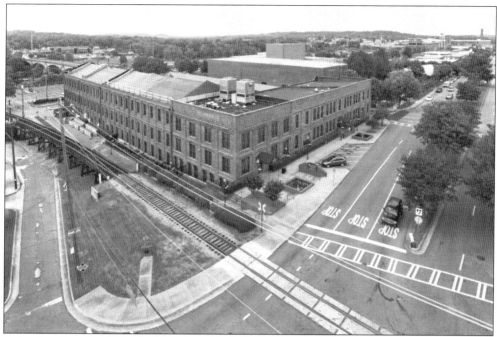

Columbus State University has been a major player downtown, investing significantly in its River Park campus. Its commitment to historic preservation and adaptive reuse has been a key part of its strategy. The One Arsenal Place Building, seen here, was once owned by the Columbus Iron Works. (Courtesy of Jim Gates and Bill Edwards.)

The Seaboard Airline Railway Depot, built in 1902, was once the freight hub for the many industries on Front Avenue and functioned in that capacity until 1971. It then was used as a warehouse until W.C. Bradley purchased the building in 1976 with plans to renovate. The building is now home to CSU art studios. (Courtesy of Lisa Roy.)

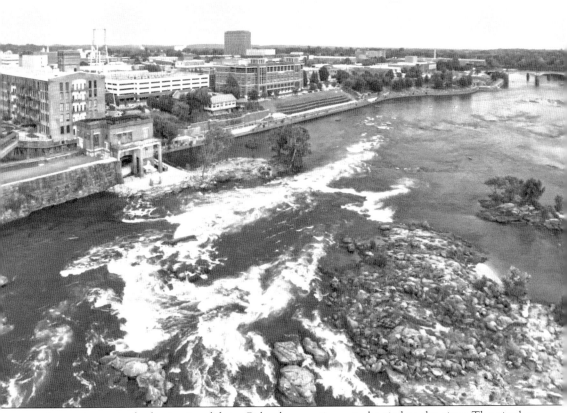

Just as it was in the beginning, life in Columbus continues to be tied to the river. The city has evolved and now has new ways of using the Chattahoochee. Old riverfront buildings have new life as luxury restaurants, condominiums, and unique shopping destinations, and a white-water rafting experience puts people in direct connection with the river. Over time, the course of rivers can change, but change can be good. Moving forward and making progress is a must, as long as the residents remember where they came from. Columbus has done this brilliantly, becoming a city that progress has preserved. (Courtesy of Jim Gates and Bill Edwards.)

INDEX

Battle of Columbus, 39, 41, 46, 47, 48, 50
Bibb Mill, 53, 69, 70, 71, 73, 76
Church of the Holy Family, 30
City Mills, 20, 73
Coca-Cola, 50, 60, 61
Columbus College/Columbus State University, 63, 101, 116, 117
Columbus High School, 97, 98, 118
Columbus Iron Works, 41, 59, 121, 125
Eagle and Phenix Mill, 40, 53, 64, 65, 70, 73, 74, 75, 79, 124
Empire Mills, 69, 121
First African Baptist Church, 32
First Baptist Church, 29, 32
First Presbyterian, 30, 42
Fort Benning, 44, 101, 108, 109, 110, 111, 112, 114
Muscogee Manufacturing, 66, 67, 73, 74, 86, 122
Royal Crown, 61
St. Luke Methodist Church, 28, 99
St. James AME, 32
Steamboats, 41, 54, 55, 56, 88
Temple Israel, 31
Trinity Episcopal, 31

Discover Thousands of Local History Books Featuring Millions of Vintage Images

Arcadia Publishing, the leading local history publisher in the United States, is committed to making history accessible and meaningful through publishing books that celebrate and preserve the heritage of America's people and places.

Find more books like this at
www.arcadiapublishing.com

Search for your hometown history, your old stomping grounds, and even your favorite sports team.

Consistent with our mission to preserve history on a local level, this book was printed in South Carolina on American-made paper and manufactured entirely in the United States. Products carrying the accredited Forest Stewardship Council (FSC) label are printed on 100 percent FSC-certified paper.